Women
Who Want To Be
Boss

WOMEN WHO WANT TO BE BOSS

Business Revelations and Success Strategies from America's Top Female Executives

Marlene Jensen

Doubleday & Company, Inc., Garden City, New York
1987

Library of Congress Cataloging-in-Publication Data

Jensen, Marlene.
Women who want to be boss.

1. Women executives—United States. 2. Women in
business—United States. I. Title.
HD6054.4.U6J46 1987 658.4′09′024042 86–16707
ISBN 0-385-23375-2

THIS BOOK IS DEDICATED TO:

Herbert Keppler, Publisher, *Modern Photography*
Francis Pandolfi, President, Scarboro Systems
George Allen, Magazine Consultant
Robert Krefting, Vice President, *McCall's*
Thomas Ryder, President, American Express Publishing
Chuck Stentiford, Publisher, *Successful Meetings*
Peter Diamandis, President, CBS Magazines

In a book about women bosses, it is appropriate to recognize help received from male bosses. These former bosses of mine (in chronological order) all stuck their necks out in hiring a woman for a previously male position. Together, they represent a wealth of knowledge about magazine publishing and management techniques. I couldn't have found better teachers.

ACKNOWLEDGMENTS

My thanks go to all the women who agreed to be interviewed, both those whose names you see and those who insisted on anonymity. They were all supportive of getting real world advice to ambitious women.

I'm also grateful to Agnes Birnbaum, my agent, who made me stop talking about this book and start writing. And to Trisha Nickel, whose research help was most valuable.

CONTENTS

INTERVIEWEES FOR THIS BOOK
(In Alphabetical Order)

Mary Kay Ash, Chairman of the Board, Mary Kay Cosmetics

Dorothy A. Berry, Executive Vice President and Chief Operating Officer, Integrated Asset Management

Selamawit (Sally) Bissrat, General Manager, The Tarrytown Hilton

Cathleen Black, Publisher, *USA Today*, Executive Vice President, Gannett Co.

Terry Bonaccolta, Senior Vice President, Management Supervisor, Levine, Huntley, Schmidt & Beaver

Helen Gurley Brown, Author, Editor-in-Chief, *Cosmopolitan*

Marva N. Collins, Director, Teacher, Westside Preparatory School

Laurel Cutler, Vice Chairman, Director of Marketing Planning, Leber Katz Partners

Doris Forest, Publisher, *Foreign Affairs*

Imogene Forte, President, Incentive Publications

Sharon Gist Gilliam, Budget Director, City of Chicago

Ellen R. Gordon, President, Chief Operating Officer, Tootsie Roll Industries

Caroline Jones, Executive Vice President, Creative Director, Mingo-Jones Advertising

Lillian Katz, President, Lillian Vernon Corp.

Kay Koplovitz, President and Chief Executive Officer, USA Network

Louise R. McNamee, President, Della Femina, Travisano & Partners

Nancy S. Peterson, President and Chief Executive Officer, Peterson Tool Co.

Sylvia Porter, Financial Columnist, Editor-in-Chief, *Sylvia Porter's Personal Finance Magazine*

Ernesta G. Procope, President, E. G. Bowman Co.

Dr. Donna E. Shalala, President, Hunter College, City University of New York

Carolyn Wall, Executive Vice President, Consumer Magazine Division, Murdoch Magazines

Shirley Wilkins, President, The Roper Organization

INTRODUCTION

(Or, Who Am I To Write This Book?)

———————————

I'd been publisher of *Audio* magazine for almost a year before I realized how I got the promotion—and that I could have been promoted two years earlier, except for my stupidity and for being blocked by a man I considered a mentor. It was quite a revelation.

Magazines have been an obsession with me from as early as I can remember; I moved from high school free-lancing assignments, to editing movie magazines, to starting my own magazine about women athletes.

It happened when Billie Jean King started getting a lot of media attention. I wanted to read more about women in sports, but the newspapers and the sports magazines had next to nothing. It was a golden opportunity for a

magazine lover stuck in a frustrating publicity depart-
ment job.

Sportswoman magazine was the result. I started it with
my total savings of $5,000 and a loan (which my then
husband had to co-sign!) of $5,000. It was first a quarterly
and then a bimonthly (at which point I was able to hire my
one and only employee). I was editor and publisher, but
also circulation director, advertising director, production
director, and chief envelope licker. In the first issue, I
wrote all but one of the articles and took over half the
photographs. I even set my own type, renting an ad
agency's type machine after business hours. It was excit-
ing and fun.

Things went magnificently for the first year and a half,
until the 1974 recession hit. I had no idea what a recession
was. I soon learned it meant my direct mail would bring in
only half the orders it used to. Newsstand sales went down
by 20 percent. The extra pages and the color photographs
I had added when Billie Jean King started her own maga-
zine were draining the cash in the bank. I was soon in debt
and looking to sell. (For a definition of fear, try having
your entire fortune of $10,000 tied up in a women's sports
magazine when Billie Jean King starts *womenSports* with
over $1 million in funding!)

Sportswoman was sold twice (a real learning experi-
ence!) before I actually got my money and took off to
France to blow every nickel in six wonderful months.
Which ended with me in New York in search of a job.

Publishing *Sportswoman* had taught me that while I
enjoyed editing, I preferred publishing. As publisher,
there seemed to be more action. There were many more
things that could go wrong and many more sandboxes to
play in. The flashy uncertain world of ad sales was entirely
different from the computer-oriented, analytical world of
circulation, the heavy machinery world of production, the

interstate shipping world of the trucking industry, and the (your pick of adjectives) world of the postal service. Also, a publisher must try to maximize three different revenue streams—advertising, subscriptions, and newsstand—each of which works against the others. Maximizing one always hurts another. It's a balancing act that brings continual variety and challenge.

I had just started researching business schools when I saw an article in the New York *Times*. In it the president of ABC Leisure Magazines said the publishing industry needed more MBAs. I wrote to him immediately and included my résumé. I suggested that he hire me because I was *planning* to get my MBA. After a few negotiations, he did just that.

I knew absolutely nothing about big company finance, but he needed a number two person in the finance department. He told me it would be no problem for someone who had done her own corporate tax returns (which I had done for *Sportswoman*). It was frightening, but I took the job, grateful for a company that would teach me on the job a skill I would obviously need for big company publishing.

Two and a half years later, I wanted out. I'd learned a lot and moved to business manager of ABC's most successful publication, *Modern Photography*. It was, however, a dead end for advancement opportunities.

Looking around for a big company with a lot of magazines and enough movement to provide growth opportunities, I focused on CBS. At CBS, I was given the position of group business manager over eight magazines. I told my boss from the first that I was eager to get back into a publisher role—the sooner the better. It was a reasonable goal. My predecessor had just been made publisher of *American Photographer*. I figured it was just a matter of

waiting until the next slot opened up. That was my first big mistake.

CBS had acquired *Audio* magazine in 1979, and almost from that day its ad pages (and thus its profits) had started to nose-dive. The whole industry was in trouble, but *Audio* was suffering the worst.

The group publisher of the Special Interest Group (who had hired me and to which *Audio* reported) had become a mentor to me. He is one of the smartest men I've ever met and he was constantly challenging me to a better and better performance. Through his critiques, my analytical skills were being honed. I was working ten-to-twelve-hour days and loving almost every minute of it.

This man knew I was ambitious for a publisher job and I knew he had great respect for my skills and capabilities. As *Audio* began to lose more and more money for CBS, I came to believe that he couldn't change the publisher. Surely if he could, he'd put me there, so the president must be stopping him. I wondered why the president thought poorly of me. I wondered about a lot of possibilities—none of them as threatening as the idea I was running from: that my problem was really with the group publisher. Another mistake.

Deciding I needed to overprove my qualifications, I took a promotion as head of CBS's Magazine Acquisitions and Development department. Here I looked at countless start-up opportunities and several dozen acquisitions, finally culminating in CBS's acquiring *Cuisine* magazine. (A former member of the acquisitions department told me the job was like making love every night but only coming once every year or two! He was right—I found it extremely frustrating to do so many plans and buy so little.) I wanted back in the real world of action. My new tactic for becoming a publisher was to get CBS to expand

its computer annual into a bimonthly magazine—with me running it.

Midway through my sixteen months in acquisitions, the publisher of *World Tennis* quit. The group publisher took the ad director of *Woman's Day,* Chuck Stentiford, and made him publisher of *World Tennis* and to my surprise— the executive publisher of *Audio* as well.

Stentiford and I had met at a CBS School of Management week-long workshop. After learning of his promotion, I invited him to lunch and tried to give him some insights into opportunities I saw in *Audio.* Coming from ABC, which owned *High Fidelity,* I'd given a lot of thought to why *Audio* was so down and what strategies I thought could turn it around. In a recession, in a three-magazine field, you will usually find the large mass book and the small, elite book doing well, with the middle-of-the-road book hurting. *Audio* was the small, elite book and yet it wasn't able to capitalize on that. I told Chuck he was sitting on a potential gold mine.

He was sitting back being noncommittal, so I found myself getting very animated and enthusiastic and determined to make him see all the wonderful upside potential just waiting for him. Then I wished him success and went back to my acquisitions job. Seven months later, he took *me* to lunch. The publisher of *Audio* wasn't making the necessary changes and Stentiford wanted me for the job. I would finally get to put my theories into operation.

Fortunately, they worked out well. In one year we raised ad pages by 49 percent, increased total revenues by 66 percent, and took 84 percent of that revenue growth to the bottom line. *Audio* went from deeply in the red to a respectable profit.

Then I ran into the former group publisher at a convention. He had since quit CBS to become an entrepreneur, and now had his own quickly growing company. He told

me he was delighted with the great things he was hearing about me. He also said he'd been surprised, because while he thought I was smart he didn't think I could sell. "You're an introvert, not an extrovert," he told me. "How do you handle all the sales calls?"

I hadn't thought about that before. "You're right, I am basically an introvert," I told him. "But I have an extrovert side that comes out in giving presentations. I did a lot of acting in high school—I even won Best Actress in our state competition. In sales, the challenge and the need to think fast on my feet give me the same adrenaline rush I used to get right before I'd go on the stage. It's fun."

"You should have told me about the acting," he said. "All I saw was your analytical side."

You can imagine my state of shock as I *finally* realized that he could have made me a publisher long ago but chose not to. This was followed by an even greater shock —that he had been absolutely right in his decision.

I did a lot of thinking. There were several mistakes I'd made that I didn't ever want to repeat. It should have been obvious that ad sales ability was a key skill for *Audio*. The publisher was carrying the ad space almost single-handedly, with just one junior salesman in the East and a senior salesman in the West. I knew my ad sales skills were suspect. The only selling I'd ever done was for *Sportswoman* and most of that had been by letter.

A mistake was made by assuming that a lack of ad sales credentials was something I had no control over. What really made Chuck Stentiford decide to risk hiring me— hindsight is perfect—is that he saw me demonstrate ad sales skills. I was selling him on the great potential for the magazine. He saw me demonstrate the generation of excitement, the high motivation, and the persuasive skills necessary in ad sales. It was something I could have and

should have done with the group publisher. If I couldn't even sell him on me, how could I sell clients on *Audio?*

I thought a lot about my blind spot during the following year, particularly when I saw other women with their own blind spots. With my position in CBS, I would occasionally be asked for advice from middle-management women. I'd always been happy to offer what help I could.

There were, however, two women who came to me thinking sex discrimination was the only thing holding them back. I was sure it was something else: in one case a very negative attitude and in the other an image of softness. I would not have promoted them myself. I tried to suggest to each that there were many different qualities that might be necessary for a job at the next level. I listed several, including those I thought were their problems, but either I'm a poor explainer or they didn't want to hear. They kept coming back to being female instead of what I was suggesting.

I wondered if I had additional blind spots myself— things someone else could see in me as I could see problems in these two women. I became curious about other women executives, especially those who had made it into powerful positions. What revelations might they have had that catapulted them up to where they are? What management techniques might they have discovered?

Business magazines run many interviews with top corporate men in which you can learn much about how they made it to the top. And I've benefited greatly over the years from high-level male advice. But I suspected there were different problems and different revelations that pertain more to being a woman manager.

There was a study I read about the effect of sales training on sales recruits. For the men, it was a very positive factor; but for women, sales training had a strong adverse effect on later performance. It turned out that much of

what works for male salespeople does not work for female salespeople. As an example, men are told it is important to be friendly and smile frequently. Women following this example are judged to be mental lightweights, coming on sexually to the client, or both. I reasoned if there were strong differences in sales, there might also be strong differences in management.

There have been a lot of books aimed at just this subject, and I've read most of them. Some are excellent, but many sounded like lessons from my MBA studies—lessons that turned out to be fine in theory but impractical in the real world. Figuring the real world answers had to be with women who had the biggest successes, I determined to interview top-level businesswomen from all walks of life and from a wide range of ages. I didn't want rules or theory, only case histories of what had happened to them in their careers. In fact, I told Doubleday I wanted to write this book because of what I could learn. I've never been lucky enough to have a woman boss—someone who could teach me the ropes as a woman manager. This book was my chance to learn from some of the best.

What happened after *Audio?* That success was the primary factor in my getting the publisher slot on the much bigger *Mechanix Illustrated* (now renamed *Home Mechanix*). A new president had just been appointed at CBS Magazines and major changes were rumored throughout the company. I assessed which magazines were likely to face changes at the top and prepared my credentials for the only two that appealed to me. When the president called me in and asked me what I would do on three different magazines (including the two I'd picked), I was ready. The fact that I was an active do-it-yourselfer, that I had just built a double wall unit that can be used as a library and office, was icing on the cake. The cake was my results on *Audio*.

After two years, the major changes on *Home Mechanix* had been completed. In 1985, when we changed the magazine name and reduced the number of subscribers—twice!—we increased our share of market in ad pages. In fact we beat all but the number one book, a far better performance than even I had expected. Our plans to continue the advance in 1986 were well laid out, requiring only their execution. The first two issues of 1986 were up 15 percent and 6 percent, increasing the rate of gain in ad page market share. In short, the fun part of the job for me was mostly over.

During the past few years, I've met several venture capitalists who stated an interest in investing in a magazine project I would run. So, armed with a consulting contract from CBS Magazines, I'm currently doing a prospectus and dummy issue of a magazine I want to start, and trying to raise the money for it.

That makes me one of the current wave of women executives who are leaving corporations to start their own companies (see Chapter 9, "Women's Management Styles"). It's not, on my part, due to a dissatisfaction with the corporate world. There are many, many benefits to working for a large corporation that you miss as an entrepreneur. But at this point in time, the biggest challenge I can find is to start up a new magazine.

And if there is one trait that I share with all the women bosses whose interviews follow, it is the love of challenges.

1

TRAITS OF THE SUCCESSFUL
WOMAN EXECUTIVE

In searching for women to interview for this book, I found
them through articles in various newspapers and maga-
zines, directories, and organizations. Approximately one
third of the women contacted agreed to be interviewed.
While this is not a projectable sample, I thought it would
be interesting to see if there were any particular traits
these women had in common.

The ages of the twenty-four women interviewed range
from thirty-five to sixty-seven, with an average age of
forty-nine. The age when they first began managing other
people ranged from seventeen to forty-five, with an aver-
age of twenty-five.

Twenty-one percent of the interviewees are Black,
with the rest Caucasian. The socioeconomic status of

these women as children ranged from lower class to upper class, averaging right in the center of the middle class. Interestingly, 50 percent had an urban upbringing, 25 percent a rural upbringing, and the other 25 percent were a product of the suburbs.

Regarding their personal lives, 64 percent are presently married. Just over 55 percent have children, and all who are parents worked (or are working) while the children were/are young.

The occupations of these women's fathers ranged from factory worker or mail clerk to attorney or company president. They were most likely (35%) to be small business owners, followed by corporate managers (15%) and blue-collar workers (10%).

Their mothers were most likely to have been housewives (58%) while they were growing up, but also represented were seamstresses, teachers, nurses, and one teacher who went on to become an attorney. The job most frequently held by these women's mothers was that of a small business owner (21%). In all but one case this was a joint business with their husbands.

Does being a teacher prepare a woman to lead a company? Over 20 percent of the women interviewed started their careers as teachers. At first I was inclined to view this as a result of the fact that teaching was traditionally one of the few careers that was available for intelligent women, but this may not be the case.

Imogene Forte is president of Incentive Publications, a company which produces books, teaching materials, and resources for creative teachers looking to generate learning enthusiasm in their students. Forte attributes a large part of her success to qualities cultivated while teaching.

She believes teaching develops your authority as you learn how to control the class. Because the successful teacher is the one whose students become successful, you

learn to nurture and develop skills. You learn respect for individual differences in people. You see that some are more capable. Others are more motivated. In each case, you need to help them maximize what they can do. Forte also says that you become used to making a difference in people's lives—which is important so that you know it is possible.

Louise McNamee, president of the $173-million ad agency Della Femina, Travisano & Partners, found another way in which teaching helps. She had been working with disturbed children before she entered business. "That was difficult," she said. "Business was easy by comparison."

Another trait that became apparent in interviews is a need to challenge themselves. Over and over I was told of safe jobs that were abandoned—tenured teaching positions, good status corporate jobs, pension plans. All were discarded in the search for growth, through new knowledge and new experiences.

Most of the women had studied their environments and learned the "rules." But they also made their own space in the system by discarding the rules they had the most trouble with. In fact there was a belief that as women they could play a little looser with the "rules" than men. "There aren't enough women CEOs in my field," one woman said, "for men to know if what I'm doing is 'right' or not."

There is occasional resentment about this situation. One woman noted, "The men get downright surly in the summertime when women wear light, sleeveless dresses while they're in their saunas—jackets and long sleeves."

These women are good at finding their way around obstacles. One woman, seeing little chance to become president of NBC or even a station general manager, switched into the more fluid cable TV industry, and be-

came president of USA Network. Another, stymied at a large ad agency, joined the start-up of a small, black agency as a principal. Temporary jobs, start-ups, and companies in trouble all provided these women with an opportunity to jump ahead of those following the "normal" advancement paths.

They also seemed to enjoy, or at least not mind, stress that others would find excessive. One woman noted, "My sister plans everything well in advance. She even has birthday cards all purchased, addressed, stamped, and ready to send a year in advance. Me, I procrastinate until it's urgent. I like to work under pressure. It's one big reason why I'm good in this job. If I find twelve holes in the dike and have ten fingers—that's great! It's a challenging problem. My sister thinks it's too stressful."

The interviewees have thought quite a bit about time management. But it doesn't mean crowding their calendars with notations for every fifteen minutes. They delegate enough to leave thought time—a rare and yet essential commodity for anyone who must guide the future of an organization. One woman told me her mail sort system, which I've since stolen for myself. Her secretary sorts everything into three different in-boxes: one for items requiring just her signature, another for items requiring a response, and another for materials to be reviewed.

One of the women running her own company told me her secretary's work is 75 percent personal. This woman entertains clients four to six nights a week, so the "personal" and "business" sides overlap extensively. She told her secretary, "Consider me a small business. Your job is to keep me afloat." Her secretary keeps everything running smoothly—the maid, the gardener, the dry cleaning, the restaurant reservations, the children's appointments. The net result is that this woman can spend twelve to fourteen

hours a day advancing the company without everything else falling apart.

These women were also resilient in the face of any failures they may have experienced along the way. "Unsuccessful job interviews didn't faze me," said one woman. "I also didn't seem to recognize my failures as being failures—they upset my friends much more than they did me. I just saw them as temporary setbacks."

Their attitude was similar to that of Thomas Edison, the quintessential disregarder of failure. When someone noted he'd failed 25,000 times in trying to develop the storage battery, he said, "No I didn't. I discovered 24,999 ways that the storage battery doesn't work."

Sylvia Porter provided my favorite—if somewhat off-the-wall—trait of successful managers. She said you could tell which middle managers would rise and which wouldn't by whether or not they read mysteries. "What is running a business but recognizing and solving puzzles (problems)?" As a spy/mystery novel addict myself, I had to agree. I've discussed spy novels with several high-level bosses, and never yet had one say he doesn't read them. Frequently they're more up on them than I am.

Make of that what you will.

Executive women are very conscious of the power and prestige of serving on boards of directors. And they are having some success in gaining seats. Just ten years ago, only 13 percent of the top 1350 corporations had a woman director. Today 41 percent do. Still, women hold just 3 to 4 percent of the total directorships available in the Fortune 1000 companies. More ominously, only 25 percent of the companies who have one female director have more than one woman on the board.

While some of the older women interviewed didn't have much in the way of degrees to help their rise, today's woman executive comes to the battle well armed. In

1986, an estimated 22 thousand women will earn their MBAs, compared to an estimated 47 thousand men. At top-rated Wharton Business School, women make up one third of the classes, compared to 5 percent in 1970.

Ten years ago, women MBAs could expect starting salaries well below those of their male counterparts. Today, the starting discrepancy is a $1000-a-year lead for males. If the woman has an undergraduate degree in chemistry or engineering, however, she can earn a $4000-a-year premium over similar males. (In fact, one of the major reasons for the financial improvement is that more women are getting their MBAs in finance instead of in "softer" disciplines.)

Perhaps the biggest surprise for some observers is the vast number of women starting their own businesses. They increased by 43 percent from a decade ago, compared to a 9.8 percent increase for male entrepreneurs. Today, almost half of all new businesses are started by women. Ten years ago, it was one out of six.

In retrospect, it was inevitable. When there are large numbers of highly educated, highly motivated women moving into business with high expectations—something has to give. When old prejudices give, these women move up in corporations and contribute needed skills. When prejudices won't give, these women do not sit still and feel sorry for themselves; they do something about it.

"I'll show them" is becoming as big a motivator for women as it has been for some men in the past. The woman a company won't promote today is starting to turn up as their competitor of tomorrow.

2

HIDDEN RULES OF THE GAME

———————◄►———————

There are two critical things to learn about any game you decide to play: what the rules are and how far each of them can be bent, stretched, or broken.

Big business is no game when you're trying to put food on the table for your family or provide shelter. Once you earn over $50,000 a year, however, you're definitely playing a game. It's a game that boys have been taking lessons in since childhood. Those lessons are called team sports and military service.

"You have to think of it as a game," says Dr. Donna Shalala, president of Hunter College. "Celebrate your victories and learn from your losses, but keep your balance. I've seen people who take it so seriously and so personally that they see every loss as a nail in their career coffins.

These people burn out early. Their marriages break up. They suffer breakdowns. If you look at it as a game then you can keep a sense of humor and perspective when all hell is breaking loose."

One thing that is not a game, however, is your choice of career. I'm in favor of crossing off your list anything that doesn't pay a nice, comfortable salary. You've got only one life. Low pay isn't too bad when you're young, but as you get older, it becomes a terrible burden. However, don't go just for the money, because you're not likely to make it.

Sylvia Porter says, "You can't be successful if you don't care deeply about what you're doing." Upper-management success requires an incredible amount of thinking, planning, strategizing, organizing, and executing. If you are in banking and find it boring, you're never going to put in the effort needed to be a big success. Pick something you care about, something you won't mind waking up in the middle of the night about, something that fascinates you, frustrates you, and challenges you. That's something you can ride to the top.

Your next move is to take only line jobs—jobs in sales or manufacturing, not staff jobs. There are successful women who head important departments in personnel, public relations, billing, etc., but the odds of them making it to the top are slim. (Of course, the definition of "line job" depends somewhat upon your industry. Finance sometimes is a "line job" and sometimes isn't. Just track the leaders and how they came up and you'll have your answer.) If there are two or three tracks to the top, pick one where you can quantify your performance, as in sales or manufacturing.

While publishing *Sportswoman* I had many opportunities to see athletes victimized by subjective judging. In diving, in gymnastics, in figure skating, an athlete's scores were often affected by the politics and prejudices of the

judges. Slightly effeminate male figure skaters never got the scores their routines deserved. Communist judges downgraded American athletes.

I knew if I were an athlete I couldn't stand it. I'd have to compete in sports with objective criteria for judging winners: first person across the finish line; farthest measured jump or throw; your opponent's shoulders pinned to the mat; hockey pucks into the net.

There are strong parallels when you examine how managers are judged. Staff departments are the worst—they call for the most subjective judgments. For example, the company got much more favorable publicity due to your press releases, but you hired two extra people and raised expenses by 25 percent. You succeeded in the goal of increased visibility, but at what cost? Could you have done it with less expense? Could you have gotten even more press for the additional expense?

Or you're vice president of finance of a company with four profit centers. Sales are up and so are efficiencies. More of the revenues are making it to the bottom line. Does the credit for increased efficiencies belong to you or to the profit center heads? Your department added people to handle the increased volume of invoicing. Was it really necessary? Isn't there room for more efficiency?

If there is even an unconscious bias against you—for your sex, your looks, your personality, your alma mater— your boss can see your accomplishments as less than they are, without even realizing he's doing it. There's enough ambiguity in staff jobs to take the glow off most good performances, if that's how the boss sees it.

Line jobs don't eliminate subjective judging, but they at least give you objective criteria to use in your behalf. Sales increase over last year. Market share changes. Manufacturing cost per unit. Profits. Even numbers that go down can be commendations—as long as the competition's de-

cline is greater. The important thing is that you can talk results instead of hanging out there precariously on a totally subjective limb.

If you haven't played football or served in the military, I recommend you read *Games Mother Never Taught You,* by Betty Lehan Harragan. And even if you've done both, I recommend another book that teaches more about competitive tactics than anything else you're likely to find, *Marketing Warfare,* by Al Ries and Jack Trout.

One of the things you'll learn is that a cluttered office is not a sign of great work output. As military personnel know, a cluttered desk represents someone who can't keep up with the job.

You'll also discard a common female misconception that the support of a higher official can be used to overcome a bad working relationship with your direct supervisor. The hierarchal structure (courtesy of the Armed Forces) ensures that your boss's boss can affect you in only two ways. He can promote you to a different department under him (extremely rare), or he can fire your boss. Otherwise, your job is entirely controlled by your boss: decisions on what office you get, the amount of raise (if any), your performance reviews, and whether to fire you.

One of the most critical lessons for women comes from football. Have you noticed that in postgame interviews, star running backs almost always mention their great offensive line? Do you know that some running backs treat the offensive line to dinner after every game? Do you think that's because star running backs are selfless, modest men? Hardly. It's because the team won't block for someone who acts like too much of a hot shot. And if your business team doesn't occasionally block for you, you can't be a star. In their eagerness to prove themselves, some women don't spread around credit and gratitude—and thus end up unprotected.

Once you've learned the unspoken rules, you can start learning how far they can be stretched. A football player who played conscientiously by the rules would be severely handicapped in the results he obtained as well as the lack of respect he would receive from his teammates. (If, in fact, the coach didn't fire him.)

All rules are, by nature, artificial. Each company has its own culture, which sees some of the rules as sacred and untouchable and others as stumbling blocks which they expect the new Young Turks to successfully sidestep.

Doris Forest, publisher of *Foreign Affairs* magazine, says, "Women are too impressed with authority. In business, some lies are part of how you play the game."

In fact, much so-called "trickery" or "deceit" is actually a part of the rules of the business game. As in football, hiding the ball, pretending to pass when you're really going to run, pretending a running play when you're really going to pass, lining up on the right when you'll run the play left—these are all part of the fun of competition. They are deceitful, but also "just" because it's how the game is played.

Also part of the way the game is played is the offensive line holding—even though it's against the "rules." If pro football really wanted to stop the amount of holding going on now, they'd have the referees call it more often. The bottom line is that what is "fair" is what is allowed, to the degree to which it is allowed.

For example, new financial products (like zero coupon bonds) are recorded as soon as they go to the SEC. At that point, any firm can steal the idea. So smart managers file plain vanilla–looking things that nobody will pay any attention to. Then later, at the last possible moment, they file an amendment.

Learning to take risks is one of the most important lessons available from sports. This is not an innate skill, or

something that comes from male hormones. Confidence in taking risks comes from frequent practice and from familiarity with all the possible consequences—and, in the process, learning that the answer to failure is to pick yourself up and try again, using what you learned from your failure to increase your chances for success in the future.

Failure is a terrible thing to children. At a certain age, little boys believe that a loss by their Little League team is the complete end of the world. But by experiencing loss after loss, and win after win, they learn that losses can be survived—in fact losses make subsequent victories all the sweeter.

Little girls were in the past shielded from most losses. Their games (skipping rope, jacks, playing house with dolls) didn't focus on losing or winning as much as on taking turns. And improving yourself. Thus the champion girl jacks player was the one who was so good that other girls would watch her enviously. She didn't go into one-on-one competition and thereby force the other girls to experience being a loser. As a result, none of them had the opportunity to outgrow the childhood belief that all loss is catastrophic.

In high school and college, girls used to compete in two areas: grades and boys. Grades were again not a direct competition. They are more like a golf tournament than a tennis tournament. In golf, you play with a foursome, but you are really competing with yourself, to better yourself. In tennis, someone else has to lose at each step of the way for you to win. Competing for grades was also a weak form of competition because girls who didn't get good grades could use the ego escape hatch that boys don't really like brainy girls anyway.

Competing for boys or for a husband only reinforced the childhood fear that competition and risk were terribly dangerous and to be avoided. While some girls developed

competition for boys to an art, most found themselves in competition only when they were in love. The risk of losing a loved one is the most emotionally threatening risk most men or women ever take. A loss is indeed devastating. Those with sports training are better able to separate emotional and personal risk from risks in a game or at work.

Nobody makes it to the top of the corporate ladder without taking risks. Innumerable small risks and two or three gigantic ones can be expected by any would-be ladder climber.

I took an enormous risk when I put my entire life savings (plus an equal amount I borrowed) into a magazine I started. Yet that move was a deciding factor in many of the promotions I was getting up to six years after I'd sold the magazine. Today, eleven years later, it is again an important part of my credentials in talking to investment bankers about starting a magazine company of my own.

Mary Kay Ash put her lifetime's savings into starting her own company. She gambled on some "crazy" ideas that were sure to fail: for example, no assigned sales territories and no sales managers who didn't start at the bottom. Her risk turned into a Fortune 500 company.

Sharon Gist Gilliam, Chicago's budget director, and Imogene Forte, president of Incentive Publications in Nashville, both left tenured teaching positions. Gilliam moved to a job paying slightly less in a federal program that got its funding year to year. "I saw it as a way to get out and meet people who could lead. I figured it would only last a couple of years, but the uncertainty was a benefit to me. I wanted something new, something that would push me."

Forte started her company while remaining a teacher, risking just her money, health, and any semblance of a

social life—until the time came when she couldn't do both any longer, and she opted to go with her company.

Cathleen Black, publisher of *USA Today*, left a secure ad sales job at *New York* magazine to take a sales manager job with a new magazine called *Ms.* "It was a big risk," she remembers, "as the establishment didn't think it would survive. And there was real hostility. When we went to call on big national advertisers, everyone would hang out of their offices to get a glimpse of the freaks. We couldn't just sell an ad page. First we had to sell a dramatically changing woman's market to not only nonbelievers but people who didn't *want* to believe.

"I didn't really see it as a risk, however. I didn't see any upside at *New York* because men held all the management slots. *Ms.* provided managerial experience and very high visibility. And it cut out years and years of slow climbing through a bureaucracy."

When you run a profit center, you will find that the course of action you believe best will almost always be viewed as ill-advised by some other "experts" in your company. You will have to consider their objections and then go with what you think best, knowing that a failure will be highlighted by all who disagree. Even worse, you will find that big companies move impossibly slowly in decision making—to the point of endangering your profit center should some decisions await consensus or approval. You will have to learn which decisions absolutely must be cleared, and learn to make the others on your own.

There is a fear of making decisions that appears to grow stronger the higher you rise in the company. Some top executives are delighted if you just run your profit center and keep them advised only where it is likely to be noticed by their bosses. All this works fine as long as you are successful. If you run into problems, you're out on a limb alone. Obvious risk. Yet it's better to fail by the results of

your actions (and thereby learn something in the process) than to fail because of corporate politics or because you were sitting around awaiting a decision from top management.

In the future, the tenfold increase in the numbers of girls playing team sports in school will produce more women managers who understand the "game" aspects of big business. Most of the women interviewed here had to stumble upon it or consciously learn it. But no matter how the knowledge was acquired, once they learned the "Big Business Game," they found it addictive.

"You hear talk about the 'sacrifices' made by company presidents," said one interviewee, "but it's a lot of bull. The bottom line of why I'm doing this job is there's nothing else I can do for eight to ten hours a day that is half as much fun."

3

TACTICS FOR THE FIRST DAY ON THE JOB

A salesman wandered, stunned, down the hall to the office of a friend. He looked as if he'd just received the death sentence. He propped his elbows on his friend's desk and cradled his head in his hands.

"My God," he said to his friend. "Oh, my God, our new boss is a woman!"

I learned about this reception to my announcement as publisher of *Mechanix Illustrated* because the salesman and I shared the same friend. I don't know who the salesman was and I don't really care—I doubt he was the only one with that reaction.

Every new manager faces resentment from those who wanted the job and those who supported someone else, as well as a certain degree of skepticism from almost every-

17

one. They're waiting to see if you're going to force change on them or cause them problems.

Women, moving into a previously male position, are watched with almost bated breath to see just how bad it's going to be. I suspect this will be the case until almost everyone has had a woman boss at some point in their career and realized it is not the end of life as they know it.

As an example, male ad directors who have worked for me have reported a number of calls from male friends in the industry who have just discovered their next boss is female.

"Is it very bad?" they ask. "What's it like working for a woman?" As if we were all alike. (Both former ad directors have assured me they tell their friends the experience is close to being in Nirvana.)

There's no one "best" way to start off with your new staff, because it depends upon the type of person you are. What works for one won't work for another. So here's how several different women have handled it, in the hopes you'll find something you can use or adapt.

The "superserious" expectations some employees have about women bosses (overachievers with no sense of humor) gives a decided advantage to women who play against it. Louise McNamee used it to good advantage at a companywide luncheon thrown to celebrate her new appointment as president of Della Femina, Travisano & Partners, a New York advertising agency. Standing at a podium, she announced, "I've decided to take this opportunity to make some changes around here. I've got a list, so I'll just go down it. My first act of power will be to order free tampons for all the women's bathrooms here. I've always been annoyed at paying a quarter. . . ." She continued through the laughter in that vein for what was surely a different introductory speech than expected.

Selamawit (Sally) Bissrat found a different set of expec-

tations when she first met her staff as the new general manager of the Tarrytown Hilton. (Bissrat is the only female general manager at Hilton.) "Some came into the meeting with their hands shaking. I think they believed I couldn't be a 'regular' general manager, being both black and female. I must be a real bitch sent in to cut heads. Or I was a token the company had to hire and I wasn't any good."

What her new managers saw when they walked in for the first staff meeting was a very small, very soft-spoken woman who exudes an air of great confidence. "I just told them I was happy to be in Tarrytown, gave them my background, and set up individual meetings for each of them to brief me on his or her department."

In the individual meetings, some opened up to her questions easily and some remained aloof, secretive, and suspicious. "I gave little projects to the ones who were uncomfortable with me. Projects where they would have to come back and discuss options with me. And in the process of working together, they were able to get to know me—quickly, not months down the road.

"I think it's important when you're new," Bissrat explains, "not to try to impress everyone with your role. Let them talk first. Give them the upper hand for the first meeting. Let them get comfortable quickly so you can soon find out how good they are."

When Dr. Donna Shalala was appointed president of Hunter College, it was December and she didn't start until September. "I didn't have a 'first day on the job' at Hunter, because by the time I got there I already knew all the department chairs and most of the problems.

"There had been some internal support for a candidate on staff, so I called him immediately. I told him I needed his help or I wouldn't be able to survive the job. We had lunch and he was a great help. I also called all the depart-

ment chairs to get their advice on what needed to be done." As people who give advice frequently support those acting on their advice, this strategy not only helped Dr. Shalala know what the problems were going in, but also gave her at least the beginnings of support.

Ernesta Procope, president of E. G. Bowman, an insurance company, serves on many corporate boards and business committees in New York. "When I'm meeting a new group that I'll be working with, I introduce myself to everyone and then find one person I can start a conversation with. I'll get to know him and then go from there."

Procope is frequently the only woman and/or the only black on a committee and occasionally encounters men who don't speak to her. "I give them the same cold shoulder back. I work with those who work with me. As the quality of what we're doing becomes evident, the others can make the decision to come over and join or be left out." Procope understands that nothing makes a person look less powerful than trying to start a conversation with someone who isn't willing.

First impressions are often difficult to overcome, and one of the first things the staff looks for in any boss is the extent to which he or she will use power. Especially with women, there is a great fear that you'll overuse it and a more hidden (but equally deep) fear that you won't use it enough.

Nobody wants to work for a wimp. In a battle for limited corporate resources—money, office space, desktop computers, etc.—employees want someone fighting for them.

Some men advise that a new manager should fire someone within the first month or two on the job. If you've got someone who should be fired, that's great advice. Firing someone who doesn't deserve it makes you look arbitrary (and therefore untrustworthy) and dumb. Still, if there's

nobody who needs firing, find something that will demonstrate toughness and do it.

"I find kindness is frequently misconstrued as weakness," says Doris Forest, publisher of *Foreign Affairs* magazine. Forest took a step down in order to join *Foreign Affairs,* starting as an administrative assistant. When management promoted her to business manager, she agreed with them to let her predecessor keep an office for three months. Forest inherited the man's former secretary, and told him he could use the secretary for his job hunting needs.

"It was a big mistake," she reveals. "Two months later I was eating lunch in and my secretary was out. I picked up the phone and found myself in a conversation about materials we had supposedly ordered. The man had a letter signed the week before by our business manager—the man I had replaced! My name was mentioned in the letter as someone who was on board to *help out* the business manager! And this letter had been typed by my secretary."

When the secretary returned, they talked. The former business manager had never stopped passing himself off as still being in the job. And when the secretary was asked why she went along with it, she said, "Well, he knows so much more about this than you, that I figured until you got up to speed on it . . ."

Forest kicked the man out of his office and fired the secretary. And suddenly people inside and outside the company were congratulating her on her new promotion as though it had just happened. Nobody had thought she was running the department until they saw her exercise power and control.

4

DEVELOPING
A SUCCESS IMAGE

What's in an image? Appearance, aura, certain actions, and expectations (of yourself and of those you meet).

Appearance has gotten a lot of press, mostly originating with people who want to sell products. There were some hefty price tags on the clothes I saw on many of the women interviewed for this book, but I didn't see a single *Dress for Success* outfit.

The clothes were pertinent to the profession of the wearer, with entrepreneurs less conservatively dressed than corporate leaders. Nancy Peterson, president of Peterson Tool Company in Nashville, dresses herself and her office meticulously. And she demands a clean, neat shop. "We do precision work here," she explains. "Any sloppy

appearance would be counterproductive; it would send the wrong signals."

The women I interviewed wore loosely structured suits, dresses, some blouse and skirt ensembles, and two outfits that included pants but did not resemble a typical pants suit. The overall impression was consistency with personality, but the personalities differed dramatically. There were no-nonsense images, the very feminine, the *très chic*, and the practical. These women dressed to suit themselves and looked comfortable as a result.

I asked a top executive recruiter about clothes. She agreed to talk on the condition that her name not be released. "No client has said anything to me about how a candidate dresses, although I have had one client object to the amount of makeup a woman wore.

"There is," she added, "one appearance problem that can torpedo any candidate—male or female. Being really overweight is such a negative that clients don't even want to see the candidates. They perceive it as indicative of a lazy or sloppy attitude that would carry over to their work; and they expect it would mean a lot of health problems on the job."

"There's also a negative perception about smokers that is being mentioned more frequently by clients."

This headhunter has not seen any problem with age being a factor. But she's recruiting for upper-management positions only. It may be a factor in lower-level hiring.

Selamawit (Sally) Bissrat, general manager of the Tarrytown Hilton, is a woman, very small, and black—all of which can be considered appearance liabilities in business. Yet she says, "Every shortcoming about yourself can be turned into an advantage." Bissrat's advantage is high visibility, which she must factor into her actions.

Your aura—or persona—is another part of your image,

and the only absolutely essential traits are confidence and toughness. A confident boss reassures the employees that they can go about their work without worrying whether the boss is about to put the company out of business. Toughness gives them the same reassurance that you can make the hard decisions necessary for survival.

Toughness comes in as many different styles as there are people, but always consists of a determination to make the company succeed, a refusal to tolerate defeat, and a willingness to take whatever steps are necessary or desirable regardless of the obstacles.

Laurel Cutler, vice chairman, Leber Katz Partners, tells a story about coming to terms with toughness.

"The hardest problem I had in my career was wanting to be loved. I would 'make nice' in situations where I should have given ultimatums. One night in the early seventies, when I was at McCann-Erickson, I was at a division party. I watched one of the art directors, about three sheets to the wind, stagger towards me and put an arm around me.

"He was a burly guy, looked like a truck driver, and he said in a very loud voice, 'I've worked for Mary Wells Lawrence and for you and I'll tell you the difference.' As he paused to take a breath, I could see everyone had stopped talking and was awaiting his next words.

" 'She's just as smart as you are, but the difference is she has balls and she's proud of it and you're still hung up on this woman's stuff.' He said it insultingly, but I was determined to hear it as a compliment.

"Not long after that another art director who worked for me, a kid ten or twelve years younger than I, took me to lunch. I thought very highly of him, as he was talented and a pleasure to work with.

"During lunch he said to me, 'Somebody's got to say no. Somebody's got to make the hard decisions. It strikes me

that you're being paid for it, so you should be the some-body doing it. I think you're looking for love in the work-place when you should settle for respect.' Now I'd been told I was too lenient for a long time, but the combination of the episode at the party and this lunch finally woke me up."

Another positive persona quality is a good sense of hu-mor. According to the executive recruiter, humor is even more important for women because most of her clients are older men who feel a little awkward with executive women. Humor enables men to relax, and nobody's going to hire someone with whom they feel uncomfortable.

Before seeing female candidates, this recruiter is often asked by clients, "Is she too aggressive? How does she treat subordinates? What's her temperament?"

Ernesta Procope, president of E. G. Bowman & Co., says men resent women who push too hard and don't know when to stop. "You must do the unexpected with men. Know when to advance and when to retreat."

Caroline Jones, executive vice president of Mingo-Jones Advertising, says, "Women in middle management tend towards all or nothing. They project a single image. They think they must be consistent. But instead they should be consistently themselves—across their entire natural range.

"One thing women must deal with is that they stand out," she adds. "They're going to be noticed. They must know this, expect it, and deal with it. Men are always commenting on businesswomen: whether they talk too much or not enough, too quietly or too loudly, how they sit, how they smoke. This is why a woman who tries to stand out looks exaggerated—because she's starting from a much more visible position than a man."

A woman member of a board of directors remarked on that same high visibility. She said she didn't realize how

strange a woman looked in the boardroom until a second woman joined their board. "It was a real shock. Your eyes would move past ten men and then land on a woman. When I found my eyes frequently settling on her instead of a male board member, I realized for the first time how I must stand out in meetings."

Yet, Lillian Katz, president of Lillian Vernon, suggests that you cultivate at least one eccentricity. "You've got to be a little eccentric to stand out from the bland mass of women and men in middle management."

Doris Forest, publisher of *Foreign Affairs,* is in a conservative, formal industry. She found that the telephone operators and secretaries would call her Doris, but would call the men Mr. So-and-so. She had to banish her first name from their vocabulary before they became sensitive to the right protocol. "When I'm placing calls," she adds, "I have my secretary give only my last name."

Some women about to get their first managerial positions have asked me how to appear powerful. They think it's a matter of the right clothes or the right tough talking. But the people who try to "act powerful" are those with the most insecurity about their power, and employees read that quickly.

The more powerful a man or a woman becomes, the more likely they are to talk quietly, tell little jokes on themselves, and *ask* employees if they would do something instead of *ordering* it.

Chicago's personification of power, the late Mayor Daley, never raised his voice above an almost-whisper, according to Sharon Gist Gilliam, Chicago's current budget director. According to Gilliam, he never gave orders. "He'd say, very pleasantly, 'This Mrs. Jones in your precinct; her husband is on disability. It would really help the family if she could have that job you have open, even if just for a little while. Would that be possible?' Now nobody

was going to be stupid enough to say no, but people are happier if they think they're choosing to do what they have to do."

Power perceptions can be affected by small—even silly —things. For example, *Home Mechanix* shares a floor with *Field & Stream* magazine. One morning, our staff got off the elevators to find the elevator bank area decorated with cover art blowups from *Field & Stream*. It looked like that was the only magazine on the floor. It was guaranteed to cause morale problems on a staff that felt at times like a poor relation.

Within two days, I had blowups of *Home Mechanix* material framed and hung so that we shared equal space at the elevator banks. But not quite equal. I have to confess to a streak of one-upmanship. The blowups I had made were spreads—so our pictures were twice as big as *Field & Stream*'s.

The most important aspect of power is: Can you protect your people? Herein lies a tale that still causes me to shake my head. A few years ago, I had a marketing director whose department was cut from five people to two, through a combination of reorganizations as well as actual cutbacks. It did not leave him a contented employee at a time when his skills were essential.

Owing to space problems, my marketing department had been located on a different floor in an area surrounded by a different magazine. The publisher of that magazine decided he wanted the office my marketing director was in, but would allow him to keep a smaller (two-window) office instead of the three-window one he was in. I told my employee *not* to pack.

Soon the facilities manager came to see me. We would have good office space for my marketing director on our floor in four to six months, so she wanted me to get him to accept the smaller office for that interim period.

Given that it was only going to be four to six months, I recommended he stay where he was until our floor was available. I told her I was afraid that the smaller office would be the final straw, on top of a decimated department, that would make him walk out the door.

She talked with the other publisher, then reported back that he refused to give in. He said the office was in his area and was his to control. I took it to the facilities manager's boss, the vice president of finance, who agreed to talk to the other publisher.

I knew what the answer would be, however. So while meeting with the president about another subject, I broached this casually, in passing. Only four to six months. For the good of CBS. The president agreed and said, "Tell [name] to cool it." This was not, however, a decision I could bank on. Given a strong plea by the other publisher, I knew it could be reversed.

When the vice president returned to me, he told me the publisher had again refused to give in. I told the vice president the president's message and he said he would carry this new situation back to the other publisher. I was already shaking my head at what was going on, and it was only just starting.

A couple of days later, the other publisher called and asked if I had a minute. I went to his office with not a little trepidation. This man had written the book on political infighting and I was afraid of being taken.

He said there'd been a lot of talk about office space and he was sure the two of us could handle it face to face. He said it would be crazy if we weren't able to solve it and had to go so far as to bother the president with such a little matter. I agreed with him that it would be crazy, even though I knew we wouldn't be having this talk if he didn't know I'd already done that.

He said he personally couldn't understand all this busi-

ness about windows. He didn't even know how many windows he himself had and he couldn't see how it mattered. I nodded in agreement, although I knew he'd been causing holy hell in the company because I had more windows in my office than he did. At the time we were meeting, he had just managed to get someone else kicked out of a larger office with more windows (equal to mine) so that he could move into it.

Between us we sketched the area in question. He emphasized that the first three-window office which my director was occupying had already been promised to *his* director. I saw a chance for a compromise. I said if his director wanted that first office, I'd be glad to move my director to the second office because it also had three windows.

He called in his general manager and told him our idea. There seemed to be no problem, so we shook hands on it. As I was about to leave, the publisher hesitated, then asked if I wanted a copy of the layout with our agreement drawn on it. "It's not necessary," I said. "I trust you."

I didn't run on my way out, but I wanted to. I felt like I was escaping from the Twilight Zone. It had been important to my employee. I'd protected him. I'd done the deal. I was glad to get out with my sanity.

One technique that quickly establishes your ability (power) to help the staff is to make positive changes your first couple of weeks on the job. For example, at *Home Mechanix* I threw out a terrible sales incentive plan and put in a great one, and I eliminated several standing policies that created needless paperwork and hindered sales for the staff.

My predecessor had told the staff all these rules were "company policy" and there was nothing he could do about them. (In reality, they were SOP—standard operat-

ing procedure—for some of the magazines but nonexistent on others.) When the staff saw how easily I made supposedly "impossible" changes, it went a long way toward overcoming their initial fears about me as a boss.

5

MANAGING THE BOSS

The would-be CEO in a corporation knows she has two jobs which hopefully (but not always) coincide: increasing profits and pleasing her boss. This chapter will look at the latter, finding both general principles and troubleshooting ideas for adversarial situations.

Good bosses' needs are actually quite simple, but non-negotiable: they want someone who will make them look good, who will be loyal, and who will show respect. There are, however, many ramifications within each of these needs.

You make your boss look good by succeeding in your job: increasing sales, cutting costs, improving profits.

Insecure bosses or bosses who are hanging on with no hopes of advancement usually do *not* want you to im-

prove sales or cut costs—at least not noticeably. They don't want you to *hurt* profits, but improvements are threatening even though they could take the credit for them. Perhaps they know that nobody would believe the credit was theirs.

Success, however, isn't enough. You must make sure credit for your success accrues to your boss. Trying to outshine your boss in an attempt to impress others and look like promotion material is a sure way to limit your future success. See how many new sales you can bring in if your boss decides you should write a weekly report on everything in your department. Or if your boss adds on some administrative tasks to your job description. Or decides you should give weekly update meetings to several internal groups.

If you are given praise for anything you've done, particularly in internal or external media, make sure you give the lion's share of credit to your boss. Nobody will believe the credit really belongs to her or him; but it shows loyalty, respect, and knowing how to play the game, qualities that will endear you to your boss as well as to potential (higher up) bosses.

If you think this is nothing but ass kissing, you obviously haven't had a terrible boss. The willingness of your boss to fight corporate battles for you, get you resources, get the bean counters off your back for at least a time, let you run with nontraditional ideas, and give you encouragement and advice instead of obstacles—all these have a tremendous impact on the amount of success you will have. Anyone who's survived a bad boss finds herself singing the praises of a good one with an almost messianic fervor.

"Bosses deserve praise," says Laurel Cutler, vice chairman of Leber Katz Partners. "*Everyone,* even CEOs, needs encouragement and reinforcement. There's no

such thing as a totally confident person—there are only degrees of confidence."

Helen Gurley Brown, editor-in-chief of *Cosmopolitan*, agrees. "I started my career at the end of the Depression, when bosses were a very precious thing to have. I still feel that way. I thank mine when each budget gets approved. And I show up at charity dinners and other functions where they need me." Brown's boss is equally enthusiastic: a chair was just endowed in Helen Gurley Brown's name at Northwestern University, in honor of her twentieth anniversary at the magazine.

Loyalty to a boss is shown in many different ways. An employee is asking for trouble if she is seen to develop a close relationship with one of her boss's peers or superiors (be this a friendship, a mentorship, or—worst of all—a sexual relationship). Bosses start wondering what you're telling this person about them, and it erodes their trust in your loyalty.

But loyalty is also shown in letting the boss know any gossip or development that could affect any part of his or her operation, not just the part you run. Loyalty is also shown by making sure the boss learns of any potential problems before anyone else (especially higher bosses) could.

Laurel Cutler was in her midtwenties when she had a boss that set her straight on employee-boss relationships. Her first day on the job, he yelled at her, "If I ever hear of a client problem from the client before I hear of it from you—you're fired."

He told her to handle her job herself until she noticed a *hint* that something serious could happen. "Instantly report it to me because by the time you perceive the hint, it's probably ready to blow up."

Cutler says her biggest indication of future superstars working for her are those who:

1. Alert management immediately to potential problems.
2. Come in with some possible solutions.
3. Make a recommendation as to which solution should be undertaken, but also ask for the boss's advice. "Say, 'I recommend we do this. Am I missing anything?' Avail yourself of your boss's experience in evaluating your recommendation.

"Of course," adds Cutler, "you don't want someone who's in your office all the time with little problems. My philosophy in managing is: I trust you to be doing your job in your usual excellent fashion unless you come to me and say you need help."

Cutler finds this advice is harder for male employees to follow than females. "Men frequently have a macho problem in asking for help. Even if they screw it up, they feel they've done better than if they asked for help."

Dorothy Berry, executive vice president of Integrated Asset Management, doesn't believe bosses want yes-men (yes-persons?). "I remember a very big argument I had with a boss. I wanted him to know I thought what he was contemplating would be a mistake. As we concluded the argument, he said, 'You're a tough woman. I like that. But will you have a problem carrying out this program if I decide I want it in spite of your objections?' I told him absolutely not. He's the boss and the decisions are his to make. I just want to make sure my views are known."

When problems occur, all the women interviewed advocated a direct approach. The most difficult situation is when the chemistry just isn't working. It's hard to pin down a reason, and without a reason it's impossible to find a solution.

Kay Koplovitz, president of USA Network, recalls a problem with a boss that made her feel like Alice in Won-

derland, going into a deep hole that just kept going down. Whenever she made a presentation to him, she found him pompous and condescending. She knew he was very disappointed with her work yet she couldn't figure out why.

"I really had to push him," she says. "I asked what he didn't like. He'd say it was X. I'd ask what it was about X that he didn't like. He'd say it was Z. I'd ask why he didn't like Z. I finally discovered there was a certain format he'd expected in presentations that I wasn't providing. Once I knew exactly what it was, I was able to fix it. And our talk eliminated what was most grating to me, the way he talked down to me. Sometimes the problem is just the tone of voice being used."

Laurel Cutler also advises a direct approach to uncover problems. "If you feel you have a problem, you can say, 'I think I have a higher opinion of what I'm doing than you do. If there are problems, what can I do?' "

Or, "Help me. For some reason I feel defensive with you. Is there something I'm doing that I could change so we'd both feel more comfortable?"

I had a boss whom I just couldn't figure out. It was like talking to an alien; my instincts were always off with him. Everything I would try seemed to go wrong. Finally I went to a friend who knew my boss pretty well. He advised me that my image and actions were very ambitious and hard-driving and that this clashed with my boss. "What you have to understand about him is that he feels people should be very grateful to this company for the job they have. He expects gratitude and loyalty. He doesn't trust someone who wants to perform well in order to advance herself or just for the thrill of it."

What an eye-opener that was to me. *I* don't trust employees who claim not to be motivated by self-interest; who pretend to care only about the company. I believe the employee who is ambitious can be trusted to do a

great job for the company in order to advance. It was obvious that my boss and I weren't even speaking the same language.

Knowing that, I started explaining our operations in light of the corporate good instead of focusing on individual achievements. It was company teamwork. While a leopard cannot change her spots (so he and I would never truly be in tune), it at least made conversation possible and sometimes even comfortable between us.

A friend of mine who is product manager for a major consumer goods company has a boss who comes up with wild—often very bad—ideas all the time. Every monthly status meeting finds him announcing a new strategy or two for her product. Fearing that her product would be saddled with the idea(s) and lose profitability, she would try to discuss the problems with each idea. It was a big mistake. She saw that any negative comments were making him furious.

Not being completely stupid, she decided he didn't like public confrontation. So she started saying nothing in the review, but setting up a private meeting with him later. This at least toned down the anger, but he wouldn't let up on the ideas. As she believed some of these ideas were really crazy, and could hurt profits by the millions of dollars, she was desperate to find a solution.

She decided to visit an industrial psychologist. Together they decided her boss didn't really care about his ideas— he just cared about being perceived as having great ideas. By asking her about other product managers, the therapist made her realize that some of them weren't putting the boss's ideas into effect and weren't being called on it. She realized he frequently forgot he had advanced most of the ideas.

The solution? Agree with the boss in meetings that his ideas are wonderful. Put any idea that would help or

wouldn't hurt the company into effect immediately and give the boss full credit. Ignore the other ideas. Although this is very dangerous, and not recommended, so far, she says, it's working like a charm.

Dorothy Berry was at a company where six candidates (she and five men) were contending for CEO. Her boss decided to require all the candidates to take a psychological test. The men took the test but she refused. Her boss said she wouldn't get the job if she didn't take the test. She said, "OK." He said she must have something to hide. Berry laughed. "If that were so and you haven't found it in five years of working with me, how critical could it be?"

Berry felt there might have been some grounds for the tests if he didn't know all the candidates. "But he'd worked with all the candidates at least five years." She also had a gut instinct that psychiatrists were uncomfortable with women and especially with women executives and that the results would be sexist.

It was a smart decision in two ways. First, she appears to be correct about psychological testing—see Chapter 16, "Corporate Ladder Climbing." Second, despite his threat, her boss did not disqualify her for refusing to take the test. While his reasons can only be guessed at, I have found bosses frequently respect toughness, particularly when it's nonconfrontational. You'll remember she joked about it, gave a good reason for her actions, and was willing to accept the consequences.

A similar example is recalled by Louise McNamee, president of Della Femina, Travisano & Partners. She was twenty-three and in her first agency job. "The chairman of the agency was a yeller and screamer; a real browbeater. I'd been there four or five months when I made my first presentation. Right in the middle of it, he started tearing into me in a very personal way. I picked up a stack of books near me, slammed them down, and

walked out the door for home. It was a Friday afternoon, so I had the entire weekend to wonder if I still had a job.

"Monday I went in as usual. I saw him in the halls about midday. He said hello and I ignored him. Finally he said, 'I think you misunderstood me.'

"I said, 'I don't think so.' Then he said, 'Well, I guess I have to watch my tone of voice with you.' After the incident, he became somewhat of a mentor, and I learned a lot from him."

Mary Kay Ash, chairman of the board of Mary Kay Cosmetics, used a boss who was undermining her to launch her own business.

"I was in effect a sales manager for the company, but my boss didn't think women could be sales managers so he refused to give me the title or the money I deserved. I opened forty-three states for them, but I always had some new man tagging along with me whom I was expected to train. They would go on to get the title of sales manager, while I was called a training director.

"When I'd suggest ideas on how to better motivate the salespeople, my boss would laugh and say, 'Mary Kay, you're thinking like a woman again.'" Ash retired from the company, angry and not sure what to do about it. Then she started thinking about how she would run a company differently—and better. Soon she risked her life savings to prove her ideas.

Even today there is a note of satisfaction in her voice when she observes, "Today, they're bankrupt and my company is in the Fortune 500."

Caroline Jones, executive vice president of Mingo-Jones Advertising, also got the last laugh on a terrible boss. In her case, the villain was a woman.

"She was really bad. She had me in charge of a temp secretarial pool transcribing research interviews. She'd promised to get me into writing, but I later found out she

told her boss I had no writing ability. Soon I was seeing bills from outside firms for research work I knew we did internally. I refused to sign them, so she did.

"She was having problems. She used to have staff meetings saying the men were trying to get us. The staff used to tell stories about her to other secretaries so the word would get out. One day when she was out, her boss came to me to ask about a research bill. I told him the truth, that that company didn't do that job—we did." Goodbye, bad boss.

Sally Bissrat, general manager of the Tarrytown Hilton, once had a boss who kept coming up with new ways to be a problem. It started from day one, but since her job represented a big promotion, she was determined to stick it out. This boss was told by the company that he had to interview her. In the interview he told her he'd once had a woman sales manager and she was always sick. Still, despite his apparent fears about her health, he hired Bissrat.

Then he wanted to date her. "I smiled sweetly and told him I never date anyone I work with. It's a principle with me."

His next scheme was classic. Bissrat's title was resident manager, which was the number two position at the hotel. Her boss then created a new job with the title of "director of food & beverage/resident manager," and hired a man for the job. The boss told her the "Resident Manager" tag on the man's title was so that the position didn't have to report to her on food and beverage matters. Naturally the man he hired was totally uncooperative with Bissrat.

When her boss was away from the hotel, Bissrat should have been completely in charge. Instead, he told her she was in charge on weekends, and the man he'd hired was in charge on weekdays. "Much as I wanted to challenge him," she said, "it was his prerogative to run the hotel

41

however he saw fit. It was my challenge to survive and succeed."

Soon the food & beverage man was badmouthing her to anyone and everyone who would listen. "One day I sat him down to talk. I asked him if he wanted my job and he said yes. I told him I wanted him to end up with my job, too, because I intended to get promoted out of there. I reminded him that no matter what the actual work situation was here, the company would always see me as the number two person, period.

"I suggested he work with me so that we could get this place running great and get us both promoted. And that's what happened. I succeeded in spite of my boss."

Managing a boss is not much of a problem when you have good chemistry: when you think alike and have the same goals (e.g. advancement). Working in that situation is one of the biggest "highs" available in business.

When that is not the case, you must get a complete, specific understanding of what your boss expects from you. If you can provide it, you'll have a satisfactory relationship. If you were able to work only for people with whom the chemistry was right, you'd spend a lot of time unemployed.

Sometimes, however, you'll find yourself with a boss whose demands you cannot meet. You'll learn a lot about yourself in these situations. Here's where you confront your own "bottom line" with regard to morals, ethics, and self-respect. You have to be a masochist to work for some bosses. Hanging in there, hoping he'll be fired, can sometimes do serious damage to your self-respect—more damage than you would suffer in getting out.

My only observation is that women frequently reach the point of quitting before they need to. Part of being a

boss is learning how to maneuver around obstacles. At the higher levels, you should spend a serious amount of time trying to find a way to make it work. If you still can't, after all that effort, then you need to get out.

6

THE ART AND IMPORTANCE OF
DEVELOPING ALLIES

The quintessential example of what happens to employees who don't develop allies is what happened to Mary Cunningham at Bendix. Regardless of your position on "Did she?/Didn't she?" by her own admission she barely gave the time of day to anyone in the company except Agee. And he threw her out when the going got too tough.

It sounds like a classical case of angry coworkers getting even by spreading rumors, fanning them, and forcing the situation out of control. A lot of chief executives have affairs with employees and some of them promote the women into elevated positions. It doesn't get out of control unless there are very angry employees trying to fan the fires. That usually happens only if the boss gives her a

position with *real* power, and if the other managers feel snubbed or insulted by her or by her indifference to them.

I have seen a revenge reaction like that, in a different case. A president of one of ABC's divisions lost his job in large part because of the efforts of staff departments he had foolishly treated like scum. Although he had enemies everywhere (if you referred to "The Snake," everyone knew whom you meant), he particularly insulted the treasury and the planning departments. While the treasury department made sure that any negative information got to the president, and that "The Snake's" numbers were slow in arriving, the planning department got even more creative.

That division president had made two acquisitions which were not making the projections in their acquisition plans. This is not unusual—I've never seen actual numbers from a property meet or better what the acquisition plan projected. And given the size of ABC, the losses and variances of the acquisitions to plan were inconsequential (ABC rounds off to the nearest million dollars).

Each month the planning department was responsible for reporting on all operations to top management. Owing to their anger at "The Snake," any and all negative results for his division were highlighted. For example, they would say, "In Division X, results are down because of Acquisition A, which is 14 percent worse than plan, Acquisition B, which is 9 percent worse than plan, and because of new shortfalls in the base properties."

Planning could just as easily have said, "Division X is on target," because the variances rounded off. Instead, every month the president and the chairman heard bad news attached to "The Snake's" name. There were staff parties all over ABC when this man was fired.

According to Dr. Donna Shalala, president of Hunter College, success is one third competence and two thirds

networking. She had to come up with some creative ideas for building allies at her previous job—Assistant Secretary of Policy in the Department of Housing and Urban Development (HUD) in the Carter Administration.

"The first year was very tough—I was always falling on my face," she said. "Carter made a big effort to bring in women, so we didn't have to fight as hard for positions as the men did. It left us unprepared for the politics. From day one the men were grabbing turf (responsibility for issues), maneuvering, and making big career plays. In a classic bureaucracy move, none of them would give out any information. I found myself missing important news and assignments." She obviously needed help.

"I developed a list of alumni from my grad school who were working for HUD—it didn't matter what kind of job they had. I contacted everyone and set up a meeting in my office. I told them I was being frozen out from information and I needed their help to survive. Overnight I had acquired allies who kept their eyes and ears open for me.

"Soon I noticed the men were maneuvering for the short term, and not dealing with the bureaucracy under them. In government, the bureaucracy stays—it's the political appointments that come and go. So I developed friends in the bureaucracy. I consulted with civil servants and treated them with respect." It doesn't sound like much, but Dr. Shalala says there were cabinet secretaries who wouldn't let a civil servant even step into their offices!

"I also don't believe in treating clerks differently from professionals. Everyone helped out tremendously. We grabbed back all the turf we'd lost and then some." Dr. Shalala will tell you with pride that even the cleaning ladies showed up for her goodbye party.

According to Sharon Gist Gilliam, Chicago's budget di-

rector, "Business really operates on friendships. That's how things get done and that's how you protect your back by getting advance warning of troubles brewing. For example, I have a report I've got to get out and it needs graphics *now*. When it goes to graphics, it could be put in its proper (low) position, or it could be moved to the head of the list. It all comes down to how we've treated that department in the past."

There's a photo lab at CBS Magazines that always gets "urgent, must have tomorrow" requests from certain magazines. Frequently, after rushing to get the work done then calling to tell the magazine, they'd be told to stick it in interoffice envelopes—it wasn't needed until next week. That's called crying wolf. I'm the only one who ever gave them work and said I didn't need it back for two weeks. They appreciated it; and when I did have an emergency, they knew it was a real one and acted accordingly.

Sharon Gist Gilliam talked about one of her managers who gets a lot more cooperation than the others. "She vests them in what she's doing. She'll tell them that she really needs their help. Sometimes she can tell them that if it goes well there may be extra funding for a project they want.

"When she's on a project deadline you'll see many others who have no responsibility for her project pitching in and helping her out. That's because she's done the same for them."

Shirley Wilkins, president of the Roper Organization, watched two of her male managers have entirely different results with a female office manager who started out giving them both a rough time. One of the men argued back. (You can tell which one he was by looking for the office with the most beat-up furniture!) The other would occasionally stop by when he didn't need anything to joke and

chat with her. Soon, when he did need something, he got cooperation.

Says Wilkins, "Civility takes you a long way in business. Thoughtfulness and sensitivity. Knowing enough not to hang over people's shoulders while they're doing something for you. Letting them know you understand you're not the only one giving them work. Respecting the value of their contributions."

Reading an organization chart doesn't tell you where the real power is. You'd miss the personnel director and the office manager, and there aren't two other people in most companies that can screw you as badly as these two. Yet many executives treat them like flunkies. Those executives lose out on prospective employees because the paperwork takes forever to get approved, and they have new employees at desks in the hall because the office space can't be rearranged.

Another powerhouse in some companies is the president's secretary—at least she is if you want to talk to him without having to catch him at the elevators in the morning or evening. I've seen a president's secretary at a company party have high-level, politically savvy male managers lined up to attend to her. A drink? Something to eat? Would she like to dance? Her wish was their command.

At many companies, including CBS, there is a modular staff system. CBS has four circulation units, each handling four to six magazines, and several production departments, each handling a group of magazines. There is a credit and collections department that assigns a person to each magazine. A billing department does the same. Ditto a business services department. As you can guess, the people in each of these departments are not equal; some are better than others. Part of my job as publisher (in my opinion) was to make sure the best people were working

on my magazine and that they were motivated to give us their best.

Good staff people never get much credit from line people. They hear when things are going wrong and seldom get a pat on the back when things go right. When staff people did something particularly good, I would write them thank you letters and copy their bosses. When I ran into people a rung or two or three above someone doing good work—I let them know what a gem they had in their department. When someone good got a promotion, I wrote his or her new boss my congratulations on getting such a good employee, and I'd carbon the person promoted.

I did it because it's only fair. But a side benefit is that you end up being a plum assignment for staff people. And you have good people managing the staff departments, who are willing to help you when you run into problems.

One side of developing peer allies is telling "shaggy dog" stories on each other. It's a trait I've frequently seen with men, but one very few women seem to have mastered. It's in essence a story that makes the person you're talking about look especially good, tough, smart, etc. The idea being that bragging about yourself is a no-no, but you and an ally can each do the bragging for the other.

For example, in Chapter 7, "How to Pick Winning Employees," I describe how I hired an ad director for *Audio*. This man is now publisher of a different magazine and someone whose abilities I have great respect for. At company parties, I've sometimes told a "shaggy dog" story about how I came to hire him:

"Aggressive? Roman? He came in to sell me a lousy little $2,000 page and you know what he did? He tells me my strategy stinks, he flips so many charts past me my eyes are spinning, and then he grabs me by my jacket and says, 'I want twelve pages now or you'll never see your

kids again.' What could I do? I bought twelve pages and then made him ad director. And I don't even have any kids!"

It gets laughs, but it's not as good as the tale he tells on me. I don't think I've learned how to exaggerate enough.

"Marlene? You want to know how tough this woman is? She decides she's going to fire this guy while we're at the Consumer Electronics Show. First she makes the poor guy work the whole show. Then she tells us all to meet her at the booth at 5 P.M. the last day. She lines us up and draws a line on the floor in front of us. Then she says, 'All those who have a job, step forward. Not so fast, Peter.' "

7

HOW TO PICK WINNING
EMPLOYEES

Hiring people is one of the most important functions of a manager, and almost everyone has a horror story or two as well as some great successes.

The one thing agreed upon by everyone I interviewed was that you can't trust recommendations. Carolyn Wall, executive vice president of Murdoch Magazines, summed it up in one sentence: "You can expect people to recommend their losers." This is because big corporations make it very difficult to fire incompetent employees.

I got a real education in this "corporate shuffle" myself, in one of my earlier management positions. I was told coming into the job that one employee was very weak but that we weren't going to fire him—we were just to help him find something else. Well, I really tried. I looked at

the job postings each week and suggested likely ones to him (he never took the hint). I called every department head in the company that wasn't a strong ally of mine and suggested him. (I tried to soft-pedal enough so that I couldn't be strung up later.)

It didn't work. Everyone else was already on to the game—it was rampant at that time. I finally told my boss I was issuing the employee a three-month warning. He didn't stop me, and when the employee didn't improve, I fired him.

This doesn't mean you can trust recommendations from a different company than the recommender. Carolyn Wall found that people recommend their friends who are unhappy with their jobs. Frequently people are unhappy because they aren't doing very well.

Terry Bonaccolta, senior vice president and management supervisor at Levine, Huntley, Schmidt & Beaver, said her one big hiring mistake came with the highest recommendations from people in her industry. She needed someone with experience for a position in an office outside the New York headquarters. The recommendations came from people in the industry whom she respected and thought of as her friends. He turned out to be a "good old boy," who hadn't kept up to date with today's sophisticated marketing strategies. When she fired him, she went back to those who recommended him and asked why. "But he's such a *nice* man," they all said.

On-staff consultants can also be a source of bad recommendations, according to Lillian Katz, president of the Lillian Vernon Corporation. "You need to trust your instincts," said she. "I let a consultant talk me into hiring a man whom I found obnoxious and overbearing, and who was hostile about working for a woman. The consultant really backed this man, claiming he was perfect for the job. What he was perfect for was causing a lot of problems

that required a consultant to help us solve." Katz solved her problems by getting rid of both of them.

"Would you date someone one night and marry them the next day?" asks Shirley Wilkins, president of The Roper Organization. "Almost anyone can look great for a couple of hours. You have to give them more opportunity to reveal fatal flaws."

Terry Bonaccolta believes in interviewing someone five different times before hiring—in different settings and with the other managers to see if he or she fits in. Most of the women agreed upon at least three interviews—one of them being for lunch.

That advice could have saved a friend of mine a lot of grief: He hired a sales manager without having a meal with the man. After the manager was on board, my friend discovered the man smacked his lips frequently while eating. He had to steel himself to discuss this habit with his new sales manager. After all, client entertaining is a big part of sales. The man tried to change, but had frequent lapses. "Smacking lips while eating" is not official grounds for terminating an employee at any big corporation, so my friend still has the sales manager, but tries hard to discourage him from having meals with clients.

A high energy level is a trait desired by most of the women interviewed. "Long hours are the nature of retailing," said Lillian Katz. "Low-energy people come to feel you're taking too much from them, while high-energy people fit the hours into their schedules more easily." As an example, she had two buyers, both of whom had new babies. "They'd load the babies into a double stroller on weekends and comparison-shop the stores. High-energy people are just more productive."

Cathie Black, publisher of *USA Today*, makes a point of warning interviewees of the time commitment required. "We close an issue every day," she says. "It's not like a

monthly or even a weekly. We go overboard warning interviewees this is not a nine to five job, but still they don't listen. Then, three months later, they're drowning."

Sharon Gist Gilliam, budget director for the city of Chicago, says, "I look for a legitimate enthusiasm and watch out for manufactured enthusiasm. It should be almost a free-floating zest for the job. I want someone who asks, 'What are the problems I'll be facing?' with a look of eagerness to get to them."

Imogene Forte, president of Incentive Publications, finds eagerness and enthusiasm more frequently from employees in the developmental stages of their careers.

Carolyn Wall warns, "Resist the impulse to sell the person on the job. Make them sell you."

"What the interviewee chooses to say or not to say can be very revealing," according to Shirley Wilkins. One person she interviewed went into detail on how badly his current department was run. She feels it showed poor judgment to criticize a direct competitor in such detail. "If I hired him, how long before he would be in with a different competitor criticizing us?" Wilkins also stays clear of anyone who has been stuck in the same position for too long.

Bonaccolta agrees. "While I don't like someone who's job-hopped every year, too long a time in one position shows a lack of confidence in the person's ability to take on new challenges."

Red flags go up for Sharon Gist Gilliam when interviewees start asking about perks and pension plans. "Nobody lasts over five years as a government budget analyst. It's a good stepping-stone position to a variety of higher paying positions in government and the private sector. Anyone who wanted to retire in the position would be suspect."

Kay Koplovitz, president of USA Network, wants deep thinkers for senior management positions, but linear

thinkers for sales. "It's not good for a salesperson to waste time on options and peripherals—it's a good way to lose a sale. Yet that's exactly what you want for senior management positions."

Since they don't trust recommendations, how do these women feel about references? They all check them. "In great detail," says Laurel Cutler, vice chairman of Leber Katz. "I check all the references they give and those they don't give." This is easiest done when you know people in the industry who have worked where your applicant has worked. Another source is to ask the references provided by the applicant for other people who know of the person's work."

Only one prospective boss of mine ever called my references. He asked for references of former bosses as well as former employees of mine. He grilled all of them for fifteen to twenty minutes, asking specific questions. I was particularly impressed that he wanted to know from a former employee if I had ever fought management to help her. It made me all the happier to work for someone who thought that was a critical trait.

Corporate culture is a big factor in whether a prospect is right for the job, according to Carolyn Wall. "Leaders create corporate cultures that reflect them. If the interviewee doesn't fit into the culture, she or he won't work out."

Wall describes the culture at *New York* magazine (where she was formerly publisher) as tough, fast, and superaggressive. There are other companies where employees are usually there for life. Where management believes it has found the "right" way to do most things so innovation is discouraged. Obviously someone who fits into one environment wouldn't fit into the other.

Wall asks interviewees questions to determine their management style. As an example, she was looking for a

manager to replace a man who had hired many of the staff and was still good friends with them. She asked her candidates, "How will you overcome the memory of your predecessor who hired these people?" The winning candidate answered, "Give me six months and they won't remember how to spell his name." That answer told Wall he'd fit right in with their culture. In a different culture, it would be a reason *not* to hire him.

While women stressed the applicant's ability to fit in, it didn't mean they were looking for a friend. Cronyism does not appear to be a female trait—at least not yet. Cathie Black emphasized, "I don't have to like everyone I hire. I'm not looking for friends. I don't need more friends. Some people find it lonely to step back and say, 'I'm the boss, not their pal.' But you can't be both."

Of course, the best way to hire is to get an advance preview of how they would do their job. Lillian Katz says you can't teach "buyer's nose"—an ability to pick what will sell and what won't. So she hands prospective buyers her catalog and has them tell her what they think sold best. She also reports she's never hired a male buyer who turned out to be successful. "They just don't have the instincts for my products."

I found a sneak preview technique myself that can work in hiring sales personnel. I was the new publisher of *Audio* magazine, and I didn't know the field or the accounts. Obviously I needed an ad director who knew the industry. I also wanted someone very good, and I believe a big sign of a good salesman is one who doesn't let down with the small prospects.

There were two other consumer audio magazines, but their salespeople weren't too interested in going to work for a smaller magazine (and one that looked like it would be out of business shortly). There were also five or six trade magazines covering the business of the audio indus-

try. Each year *Audio* magazine had run one or two ads in several of the trade magazines, spending a total of $35,000 spread over five magazines—not the giant account a salesperson drools over.

First I called several clients and got their opinions about the salespeople for each of the trade magazines. Then I called the most highly recommended person at each magazine and said I was planning next year's advertising and would like to get their pitch. What a difference I got in responses!

One salesman came in smooth and fast talking, but had done absolutely no homework. He didn't know what we'd done in the past and he hadn't given any thought to what problems we were facing. One woman told me she would be too busy for the next month doing budgeting, but would send me a media kit and rate card.

Only one person came in with a well-thought-out, targeted pitch that considered what we would be looking for. He was also aggressive. He told me my predecessors weren't very bright spreading ads over several magazines because they got lost in the shuffle. He gave me the "opportunity" to show I was smarter by taking all our $35,000 and putting it in one magazine—naturally his. He asked how we could tell our advertisers about the importance of a concentrated campaign when we weren't taking our own advice. He showed me Thorndike's Memory Curve, which shows how fast people forget even meaningful material (70 percent forgotten in thirty days)—which was even more reason we needed to be in each monthly issue.

Naturally I took the only possible actions: I put all my trade advertising into the magazine he was selling and then hired him as my ad director.

Which brings us to the question of whether women bosses are prejudiced toward hiring women. In general, women bosses hire a much larger percentage of women

than do male bosses—but it's impossible to say whose prejudice that reflects. Many of the women I've interviewed take care to have a sexually balanced staff. One claims to get flak about the number of women she hires, and has therefore occasionally given preference to male candidates when her female staff ratio was getting high.

I don't believe in single-sex departments, and will hire accordingly, although I won't settle for less than great employees. I have found, however, that others (especially men) don't share this concern. When I was group business manager for CBS, I had three associate business manager positions reporting to me—two women and one man. When I had to fire the male, I looked for and found a good male to replace him. Then I was promoted, the male got my job, and over the space of a year both of the women left for better jobs. He refilled all the positions with men.

In a sales environment, I've found it works well to have one male and one female in the top two positions (e.g. myself as publisher and a male ad director). There are clients who feel more comfortable dealing with women and others who feel more comfortable with men, and by having a selection at the top, the salesperson can pull in the head honcho most likely to help get the business.

As examples, I once had a good ole boy client nicknamed "Killer" on whom I never called. I also had some women and some men clients that my salespeople were able to see only because they were bringing me along. (Lots of people wanted to see what a woman publisher of a mechanics magazine looked like!)

"How do I pick good employees?" said one woman boss. "I assume they're all lying. I investigate their past because I believe more in how they have behaved in the past than in how they claim they *will* behave in the future. I meet them several times to give them a chance to screw up and let their false image slip. And I make very sure I know

what the job is I need done and what type of person is likely to do well in that type of job.

"If they can pass all of this, then I look for chemistry. If you can, hire people who will make the office more fun—in a challenging, friendly rivalry type of a way. If people can laugh while they work, they'll work harder, get more done, and have more energy left."

8

WHEN AND HOW TO FIRE

Q. When is a $100,000 plus salary not nearly enough for what you're required to do?
A. When you have to fire someone.
Q. How can you tell if someone is a poor manager?
A. If he or she hasn't fired anyone.

Firing employees has ramifications in many areas for the woman boss. It can be a show of toughness, an act of justice, justifiable revenge, and occasionally even an act of mercy. More and more in large corporations it is an act requiring incredible political skill, courage, determination, and luck.

While there are people who seem to enjoy firing employees, they are thankfully pretty rare. The worst case I ever saw was in an ad agency where I worked. It was a

thirty-five-person shop, totally under the thumb of the owner/founder. When I was fired after nine months, there were only four people in the agency who had been there when I started—and that included the owner! We used to have a Friday pool, betting who would get it that week. I watched the owner bring in two "fair-haired boys," one after the other, who were supposedly given the authority to straighten up the shop. But almost as soon as the owner gave authority, he started taking it away piece by piece until his infatuation with his latest manager finally faded and the man was fired.

None of the employees had any illusion they were working at a long-term job, so many started picking up free-lance jobs, which they would work on at the office. I'm sure he never got more than four hours of work a day from any of us. Which is what always happens to tyrants.

The other side of the coin is equally bad, however. I've worked on company divisions that were going down the tubes (and would take a lot of people's jobs with them) because the manager was too big a coward to fire one or two bad employees.

While you shouldn't expect justice in the business world, the best managers create as much justice in the departments they control as is possible. When one employee isn't pulling his or her load, but management doesn't do anything about it, it creates injustice for those who *are* doing the job. Over time it affects the morale and productivity of the good workers as they begin to slide down to the poor employee's level. After all, why should they knock themselves out when Joe next door gets as much money for half the work? There is a double standard existing between large public corporations and small private firms in their ability to fire poor employees. Disgruntled employees who have been fired seek attorneys who will file suit on a contingency basis, and attorneys are

more likely to take a case against a CBS or an IBM than against Joe's Shoe Repair Shop.

As a result, in large corporations it is incredibly difficult to fire people for honest reasons. How do you quantify a bad attitude? How can you document ineffective presentation skills? Instead, you must search for quantifiable, demonstrable reasons that make sense to a court of law instead of making sense in the business world.

As an example, I inherited a sales employee in an office outside New York. He was producing only one or two advertising pages a month (if I was lucky). His competitors from the same region were producing four to seven a month. That didn't prove he was bad (there may have been extenuating circumstances) but it certainly raised a red flag. I went out to the office and made calls on clients with him. His presentation was flat, uninspired, and not likely to sell heat to Eskimos. Worse—he got lost trying to drive to the majority of the clients we saw. Clients he supposedly had been calling on for the past twenty years. It became obvious he'd been coasting for years.

Despite lots of suggestions and work on my part, nothing was improving. But the corporate attorneys wouldn't let me fire him. He was sixty years old, had apparently done a satisfactory job for twenty years (no one had letters on file stating otherwise), and had received satisfactory ratings from his bosses. Now here comes this young whippersnapper manager who decides he's no good. What makes her smarter than his bosses for the past twenty years?

He can't find clients' offices? Well, maybe his memory is getting a little bad. His territory is doing poorly compared to others? Well, maybe the magazine is harder to sell in that region than its competitors. He's terrible on sales calls? Quantify that. What are the exact parameters of an "exciting" presentation versus a "lackluster" one? He

doesn't respond well to questions about the magazine? Quantify the norm for the other salesmen in responding to questions.

I've fired five employees in my career, and I've been sick to my stomach before talking to each one. But a situation like the above also makes me angry. There are a lot of people looking for a job or a promotion who would give anything for the positions some people are abusing. There was someone out there who would appreciate this job. There were also the jobs of the entire staff to consider as the magazine was losing money. I refused to give up.

All salespeople were required to submit on Fridays a list of accounts that they were meeting with the next week. This let me make sure the right accounts were being covered and enabled me to discuss with them in advance strategies for selling certain difficult accounts. My problem employee had been sporadic at best in doing this. I had considered it the least of my problems with him, but then I saw my opportunity.

When any salesperson missed the Friday due date, a letter went out with a copy to the file. All the other salespeople were submitting theirs on time. My problem employee almost never did. The salespeople were told to divide their account lists into A, B, and C lists on the basis of priority and submit their lists for discussion. Everyone else did except you know who. The memos escalated to warnings and then a final warning. When he didn't shape up, I had him on insubordination—probably because he just didn't like to write reports. If he'd submitted his work as the rest of the staff did, I could never have gotten rid of him.

So how did his replacement do? Within three months the territory had gone from maybe a page or two a month up to ten to twelve pages monthly. And when I made calls with the new employee after two months, we didn't end

up on the side of a turnpike searching through a street map.

This willingness to go to great lengths to weed out bad employees was frequently mentioned by the women interviewed. Two of them actually went after Civil Service employees. Sharon Gist Gilliam, currently budget director for Chicago, says that it once took her a solid year to get a nonperformer fired, but she considered it time well spent.

"I believe in an honest day's work for an honest day's pay," says Gilliam. "I had to compile enough papers for a complete book, but I did it."

Dr. Donna Shalala, president of Hunter College, arrived at her new job to find trash everywhere and several Civil Service cleaners who were flagrantly not working.

"I built the cases and fired ten of them," she says, "although two were able to get reinstated." Equally important to her was the improved productivity from the rest of the staff.

According to Cathie Black, publisher of *USA Today,* "You have to clean out the bad seeds, or they're like cancer cells which can spread to the rest of the body. I also think it's good for new people to periodically be added to the staff. It puts people on edge, makes them more competitive, stimulates better performances."

Nancy Peterson had just taken over the Peterson Tool Company, after the death of her husband, when she discovered a lead man on the line was stealing small items from the company. He was an extremely valuable employee, but the others knew he was stealing and knew when she found out. "It was important for my leadership that I fire him. It told everyone what the rules were and also said I wasn't afraid of running the company without a talented employee."

Peterson also encountered employee drug problems. "I

give employees using drugs two options: treatment or being fired. Two employees who elected treatment reverted and were then fired."

Lillian Katz, president of Lillian Vernon, has an interesting rule for firing: "If we find an employee is discussed at every management meeting for a period of time, we'll dismiss them. They are taking up too much of management's time."

Katz, who had just reorganized her company, also observed, "People let go in a tightening up shouldn't have been there in the first place."

"Superiors don't fire employees," says Carolyn Wall, executive vice president of Murdoch Magazines. "The employee's staff does. As a boss, you can't give power to a new manager. He or she must assume or *grab* the power. And if the manager's style is incompatible with the style of the staff, the staff may revolt. Then you have to fire him or her, but it's just the signature on what the staff already decided."

New managers who thought bosses were so powerful are shocked to discover serious limits to the power. If you give an order and the staff won't obey it, what do you do?

There was a situation like that at CBS. A new publisher was hired for a magazine where the ad director thought he should have been promoted to the slot. Nothing unusual about that—new managers almost always face resentment. What was unusual was that the new publisher was never able to assume the leadership. For whatever reasons, the staff rejected him. They kept him poorly informed, agreed to whatever he asked for but never delivered, and in general ignored him. Management liked the man, but had to let him go because it became obvious that his staff was keeping him in the dark.

"You know what the most serious problem in firing will be over the next decade?" suggested three of the inter-

viewees. "It'll be how to handle the problems that will be created by the disappearance of the mandatory retirement age."

When employees reach their sixties, a portion of them start slowing down and lose the edge that made them good, productive employees. Most large companies had no qualms about carrying them to some extent for another year or two until they hit sixty-five and retired. But few managers—or companies—can afford to carry someone indefinitely. Which means that instead of ending their career with a nice retirement party at the office with congratulations on a job well done, substantial numbers of people are going to end their careers being fired.

It is a terrible choice: Force good employees to retire for no logical reason, or let them work but have to tell other employees they're no longer good enough. There may also have to be changes in the thinking about age discrimination cases. Otherwise, the courts could soon be packed with seventy-five-year-olds suing because they've been replaced with someone younger.

The trend is to offer early retirement plans and hope those employees doing poorly will know who they are and take advantage of the plans. There is a serious drawback to this, however. When CBS made an early retirement offer, my best salesman took advantage of it. I know I'm being selfish, but he was bulldozing all over our competitors and I could have had at least another year of his excellent work if it hadn't been for the plan. On the other hand, it helped ease out with pride intact several people who would otherwise have been fired.

As the IRS has discovered, there are ways around almost any law if you're determined enough. Here are two schemes for getting rid of bad employees in large corporations. (For what it's worth, both were invented by men.)

One is extreme, and I've only heard of it happening

once (at a big oil company). You have to be CEO of a company and have a friend/ally who's CEO of a company which employs similar professionals. If you have an employee you absolutely cannot get rid of, you can get your friend to hire the employee away with a great job. Once on the new job, the new company can decide after three months that the employee isn't working out and fire him or her. Of course, you can expect your friend to require the same favor of you in the future. (For this reason, I would advise any employee close to retirement to be wary of job offers that sound too good to be true. They may be exactly that.)

The second scheme can be used by practically any boss. The man who told me about it pays no attention to what his employees submit for their T&E expenses, and lets everyone know it. He delegates their approval to his secretary and tells her not to even bother looking at them. Then, down the road, if he wants to fire someone, he calls in the auditors to check the person's T&E report. The two times he's used it, he got them both on submitting fraudulent expense reports. It's a subtle, rather nasty scheme, because it requires the employees' collusion in their own downfall. After all, if the employees didn't submit false reports, they couldn't have been fired for it.

Another example of the battle between government rulings and business logic on what is grounds for termination was encountered by a friend of mine. One of her Los Angeles territory salesmen quit and went to work for a vicious direct competitor. The salesman now covered the exact same clients for the competitor as he used to for her. Tough luck, you say, but it happens all the time.

He left a little time bomb sitting in my friend's office—his former secretary with whom, as a married man, he was having an affair. She had access to information that could be financially valuable to him: who his replacement was

seeing, what new business he'd uncovered, who was suddenly talking increased spending, to which clients he was making a major presentation, etc.

My friend did not believe in placing such temptation in front of employees. She also felt she would be stupid to trust in the "moral integrity" of the two, given the situation.

She immediately looked for other departments within the company where the secretary could be transferred, because she was a very good secretary. Unfortunately, no one else in the office needed a new secretary or was willing to switch. So she went to personnel to tell them she needed to fire the woman. The paperwork at that office was at a standstill. Nobody would let that secretary do any work that would give her information, so nothing was getting done.

The company attorneys advised my friend that IBM was sued and had to pay $750,000 for firing an employee in a similar situation. She would not be allowed to fire the secretary. Her L.A. manager then had a solution—he wanted to call up the former employee and threaten to call the man's wife if he didn't get the secretary a job with his new company. My friend said she came very close to okaying it; she was that desperate.

Then the personnel director had an idea. The L.A. manager was told to talk to the secretary. He said he knew things were uncomfortable for her and wanted to help in whatever way he could. He also told her that he knew she and her friend were in a vulnerable position because of all this. The two competing companies have occasionally learned inside information about each other. The head said he realized if that happened, she and her friend would get the blame even though they were perfectly innocent. He said he was not firing her, but would help her to find something else in any way he could, from

71

giving recommendations on her excellent skills to giving her time to go on interviews.

Solution? Not at all. The woman spent no time job hunting.

Then suddenly, after a month of turmoil, the secretary quit. Probably because of the stress she was under and because the work had become terminally boring. Since nobody would give her any work that yielded information, she was reduced to folding media kits, labeling envelopes for promotion, and spending a lot of time at her desk looking at her hands. Since she was a bright woman, she couldn't stand it. Some employees would have enjoyed an almost-no-work job.

In this case, the law hurt everybody. The company, because work backed up and management and sales productivity dropped owing to everyone's frustration at the dilemma. The secretary, because she had a lot of stress, followed by being out of a job.

Had my friend been able to fire her, the secretary could have saved herself the frustration and had a severance package.

9

WOMEN'S MANAGEMENT STYLES

(Why Can't a Woman
Be More Like a Man?)

Given that the desire to increase profits is the same, do women take a different route than men? Do they manage differently? Are they leaders in the Japanese "consensus" style? Or is there a wider variance between the extremes of male management styles than between the "average" male and "average" female style? Two interviewees said they thought there were no material style differences between men and women managers, while all the other women disagreed.

Some thought differences in style and tactics may be due to cultural expectations rather than instinctual differences. For example, most people find style differences between very short male managers and very large (tall

and burly) ones. Although there are certainly exceptions, there is usually an overt toughness in the very short male manager, and there is frequently a gentleness in the very large male manager. This is because a manager must be imposing but not terrifying to get the best results, and the smart male manager naturally beefs up whichever part of the equation may be needed to complete the image.

Women, likewise, face preconceived expectations which must be factored into their behavior in order to get the best results. Kay Koplovitz, president of USA Network, notes for example, "Male managers treat their staffs more callously than women, and that's considered okay. 'He's demanding' can be said about a man who treats his employees like dogs, but a woman with that behavior would cause a full-scale revolt."

Koplovitz believes the differences go even deeper. "Women are better at matrix thinking and managing, while men are more likely to think and manage linearly. Women are used to complex, less clear-cut issues. They're used to juggling many things at the same time. They may do better at the Japanese team management approach.

"I've had to learn this, myself," she says. "I'm naturally very direct. I like to make decisions and move on. I've had to learn to seek the counsel of senior managers and build a consensus. One way I've approached it is to give my senior managers insight into areas other than their specialties. I get our sales, programming, and business managers into a room when we're discussing new program decisions. It works because it expands the ideas and options. And it ensures complete company support of the decisions."

Dorothy Berry, executive vice president of Integrated Asset Management, observes, "Women are usually more careful of their employees' egos than men. But they are usually more direct and honest also. Women will tell em-

ployees what's wrong. Most men wielding power are not direct unless they're stamping their feet and screaming. They're more oblique.

"Of course, being direct can be a political liability," she adds, "because a devious peer sees all your cards without showing his." Sometimes, however, being direct can be the height of deviousness, because nobody expects it in the corporate environment. They always think you're hiding something else.

"My management style?" asks Berry. "I use a lot of humor. I think it's most important in successful management. It breaks the ice in meeting with new people and it defuses touchy situations. I will also say, 'I made a mistake.' And I don't worry that I might have already said it once before this week.

"I give people more authority than they can handle. Then I watch closely and encourage them to get advice whenever it's needed. I make sure to stand back enough so that the successes they achieve are perceived as theirs.

"One of my most important functions is to act like an umbrella—protecting the staff from above. I try to filter commands from on high so they don't insult or demoralize the staff."

This doesn't mean, however, that Berry will tolerate fools, such as employees with a mistaken sense of priorities. She was on the phone once with the chairman about a major new offering, when a question came up that required verification. Leaving him hanging on the phone, Berry went to the appropriate file cabinet to get the answer. An employee was using the drawer above the one she needed.

"Excuse me," she said, "I have to get in this drawer." "When I'm done filing," was the employee's answer. Berry's reply? "I don't know who gave you power over all file

75

cabinets, but you'll have to get your paycheck from that person if you don't stand aside immediately."

Imogene Forte, president of Incentive Publications, says, "You have to give creative employees the right to fail, or you'll never get new ideas and inventive flair. In fact, I give all employees the freedom to develop their own ideas. But I won't tolerate someone who won't play on the team. It's even more critical in a small company. Everyone must be willing to pitch in with what needs to be done."

Louise McNamee, president of Della Femina, Travisano & Partners, says, "I have zero tolerance for turf confrontations. I'll penalize anyone getting into it. I know men have always understood that power is territory. But turf battles don't help the business. With a small company, you can know which people are the superstars, so it eliminates the only legitimate need for turf fights."

Dr. Donna Shalala, president of Hunter College, says women can more easily put their egos aside for the good of the company. For example, at HUD, the department had lost a grievance case from an employee who wanted a public apology in front of all employees. That was to be the settlement. "My predecessor wouldn't do it," says Dr. Shalala. "He said he wouldn't because it was stupid. But there's nothing smart about getting the department in more hot water. I did it. I refused to allow any chuckles. Then it was over."

She found herself apologizing again at Hunter College. A radical black minister showed up late for a speech the students had arranged. The technician handling the lights wanted to go home. He waited an extra fifteen minutes over the contracted ending time, then shut off the lights while the minister was still talking and went home.

The students were in an uproar. They decided it was an example of racism. Public indignation was growing more

and more heated. Dr. Shalala gave an apology and had it printed in the next issue of the student paper. She said, "I apologize for the insensitivity of the school. We don't interrupt speakers of any kind."

She says, "You can't overestimate the value of an apology. It's frequently the cheapest, fastest way to solve problems that develop. And it doesn't hurt my sense of self-worth."

The only thing that drives Dr. Shalala up the wall is people who push secretaries around. "I like hard-driving, aggressive managers," she says, "as long as they channel their aggressiveness. The only times I've ever lost my temper were when subordinates were being abused. I consider it intolerable."

Dr. Shalala believes in being visible and available to her employees. "At HUD, we had eight hundred employees, and I knew the names of at least five hundred of them. I also have my secretary schedule 'walking around time' into my weekly calendar. It's important to get out and talk to the staff, or you lose touch. If it isn't in my calendar, then I always get too booked up to find the time."

Selamawit (Sally) Bissrat, general manager of the Tarrytown Hilton, agrees. "You have to walk the property. And I see each department head every day. If they don't come see me, I go see them. On the very rare occasion I haven't gotten out of my office by the end of the day, my staff starts dropping in to see if anything's wrong!"

Bissrat once had a "style" problem with a new employee. "Our regular weekend guests are looking for a party atmosphere. They want the employees socializing with them, playing sports, adding to their enjoyment. As regular guests, they figure they deserve special attention, and they're right.

"I'd just hired a man who was very good, but whose style was very different. He appeared aloof and was invisi-

ble as a manager. Knowing that, I made sure to tell him about a forthcoming weekend baseball game he should attend. It was guests against the employees. Yet, the game came and went without him."

Bissrat saw him on Monday, standing with other employees. "Where were you this weekend?" she asked. "We missed you for the game. You let our team down. We needed you."

Why not just lay down the law to him? "I'd rather employees decide themselves to take the right actions," said Bissrat, "than be muscled into it." Bissrat used this employee's reluctance to be visible to advantage by making his absence from the group conspicuous. And it worked. Later games found him in attendance. "Of course," she added, "if that hadn't worked, I would have then insisted."

As someone who also uses muscle only after other means fail, I believe that people are hypersensitive to real power in the hands of a woman. They feel the weight of that power more than they do if it's in the hands of a man. Thus its use needs to be more circumspect. I've also found that once employees know the power *will* be used if necessary, they tend to be more conscientious in an effort to avoid having to experience it. So less muscle *needs* to be used by women than by men.

Sharon Gist Gilliam, Chicago's budget director, manages by saying, " 'I need your help.' I never threaten or remind people that I control the purse strings. People know it and know I have the power. It isn't necessary to remind them of it.

"I'm also very much a delegator. Once you've chosen your staff and paid them salaries, you must let them do their jobs. Don't stand on their shoulders. People who overcontrol do it out of insecurity—fear of making an

error. But everyone knows if you don't delegate; you'll take the full rap for mistakes anyway."

Lillian Katz, president of Lillian Vernon, had the opposite experience. "I've learned not to delegate until *I* feel comfortable about it. I once trusted some employees and ended up with an overstocked inventory."

Katz believes it's important to keep a small-company mentality as you grow. "I try to know everyone's name, get *all* my managers together every three months, and share information on how we're doing."

Katz also believes in easing employees' minds about personal concerns to enable them to concentrate on business. "I don't want women with children to feel they can't cope, so anyone traveling for me can call home every night if needed. And when managers have to be out of the country for four weeks or more, I let their spouses join them."

Terry Bonaccolta, senior vice president of Levine, Huntley, Schmidt and Beaver, raised the problem of managing outer office employees, especially those working on their own. "We have six field people across the country who work out of their homes, so I've developed a set of routines that keep me on top of what's happening.

"While their supervisors talk to them daily, I talk to each at least once a month, and also talk to several of their clients. Then every two months I travel, meeting them and some of their clients. Every call they make requires a call report. I sign off on all call reports before they go out. This lets the account people know I'm reading them and lets the clients know I'm on top of it.

"We bring our field people into New York twice a year to update them. They get a chance to vent their problems and to brag about their successes. It's helpful for them to meet and get ideas from their counterparts. We also bring them to New York for the Christmas party. It's important

that they know they have support and resources they can depend upon."

Bonaccolta throws a New York staff party every couple of months and has an open group lunch every month where all employees can air problems and contribute suggestions.

"A big part of successful advertising," she says, "is to find out quickly about problems, so they can be solved." Bonaccolta keeps wired in by a lot of phone calls. "I call clients and I call dealers. We chat. I ask how things are going. I'll ask when they were last called on and what was discussed. I'll ask them if they need anything they haven't gotten. It's a friendly chat, but it's also client research."

Bonaccolta found herself in a no-win scenario early in her career. She started a job and found a subordinate undercutting her with the client. "She was a poor employee who didn't know the business at all, but she had a good personal relationship with the client. If I'd tried to fire her at first, the client would have sided with his friend and believed all the bad tales she was telling. Instead, I just maximized my contact with the client until he could see my abilities for himself. As he saw the sophisticated marketing that I was bringing to his product, he realized where the shortcomings really were. His support for my subordinate evaporated and she quit before I was able to fire her."

Cathleen Black, publisher of *USA Today,* says managing salespeople brings special problems. "Good salespeople are very wily. They'll always push to see how far they can go and what they can get away with. Frequently they'll try end runs around their bosses. I'll always listen, but I don't encourage it.

"One salesman got fired because of it. He got a new manager whom he ignored. He tried to work outside his

boss. And then he was shocked when the manager got rid of him.

"Another way they try to beat the system is to push for special case status. 'Just look at my numbers,' they'll say. 'I'm doing great so it shouldn't matter what hours I work.' But nobody here works 9:30 A.M. to 4:30 P.M. no matter how good the numbers are. You have to show them the limits."

Carolyn Wall, executive vice president of Murdoch Magazines, says "It's important to dwell on your mistakes. It's not enough to understand it was a mistake, you need to go back to the cause. What was happening? What didn't I pay enough attention to?"

Shirley Wilkins, president of The Roper Organization, says you must sometimes encourage your staff to make mistakes! She had a bright, young creative worker she thought should be providing more ideas for the *Roper Report*. She knew he had good ideas, but he had problems writing up the questions. He lacked polish.

She told him, "The next two issues, you write up the questions." He paled. Time passed and she asked about it. "I'm working on it," he said. More time passed. She called him into her office.

She told him, "Your problem is that you're trying to give me an 'A' paper. I don't want an 'A' paper. Give me your ideas even if the wording isn't perfect." He had great ideas, and over time he also learned to write the questions well.

"When we have projects," says Wilkins, "I'll call in individuals and give them an entire project. I tell them to run it; I'll just answer questions. They're always terrified at first. They make mistakes. Mistakes can be fixed. They'll make fewer next time. Then you have someone who can run projects.

"I made a mistake once when I started that was so bad it

had to be explained to top management. My boss told me where I went wrong and said for God's sake don't do it again. Then he took responsibility for the mistake. I never forgot that and I've tried to be the same with my employees. The mistake maker feels bad enough already. They don't need a sermon on top of it."

Wilkins feels staff infighting is a serious cause of productivity declines. "I take a hard line with it. I'll tell both of them I understand they have a problem, but there's no place for it. They can work it out or one of them can decide not to work here. I've changed job descriptions occasionally, or reporting lines, to minimize the chance for clashing between two valuable employees. But if there's nothing structurally I can do, then they have to work it out themselves."

Ellen Gordon, president of Tootsie Roll Industries, had a long-term employee whose new manager was giving him bad ratings, claiming he was neither creative nor diligent. She transferred him to a different manager, and suddenly he was performing very well and was a candidate for promotion.

According to Gordon, "Not only does such a change eliminate any bad chemistry, it also motivates two people to succeed. The employee wants to show that his bad reviews were just due to the prejudice of his former boss. And the new boss wants to show that he is better than the former boss at managing employees.

"Your staff should know more about what they're doing than you so I see my job as unlocking their creativity. They have the answers for improvement that you need."

Caroline Jones, executive vice president and creative director of Mingo-Jones Advertising, had a more physical confrontation with an employee. After some soul-searching, she had hired an art director with some problems. She told him, "You are very creative, but you have poor

work habits. I'm hiring you but I want to see some progress in your work.

"This risk didn't pay off. He continued to stay out of the office during the days and work through the weekends. He'd order type in eighteen sizes and colors just to see it. And he wouldn't show anything until it was completed."

But the final straw came with some work they were doing for a Caribbean country. She'd warned him up front to double-check the colors of the flag with someone else because he had a color vision problem in the red/orange range. He didn't, and the final work went out with the colors of the country's flag incorrect.

A corrected version was immediately prepared, but someone had to blow several hours on a round-trip plane hop to deliver it. Jones decided it should be the art director, because it had been his mistake in the first place. He refused.

Jones told him he either took the plane with the new version or he was out of a job.

The man grabbed a cardboard tube, yelled, "You bitch," and hit her over the head with it.

Jones sent someone else on the airplane with the corrected version. Then she had two people pack up the contents of the now-former art director's desk and hand it to him. A few days later when the "attacker" called to apologize and ask for his job back, she just laughed.

If you read the list of interviewees for this book, you'll notice that 35 percent of the women interviewed got their "president" title by starting their own company. Business publications talk about the "invisible barrier" preventing middle-management women from breaking through to the top. At the same time, articles are starting to be written about the exodus of women from corporate

middle- and upper-management into their own compa-
nies.

Of the women interviewed here who rose within corpo-
rations, fewer than 10 percent came up the traditional
route followed by most men. I started my own magazine
years before a corporation would give me another shot at
being a publisher. Cathleen Black took a gamble on two
high-risk–high-profile new publications—*Ms.* and then
USA Today. At the time, few people thought either one
would succeed. Dr. Donna Shalala didn't rise through the
university hierarchy to become president; she transferred
to the position from the Jimmy Carter administration.

Louise McNamee didn't take the traditional male cre-
ative or account management routes to ad agency success;
she started in research, designed her own motivational
research arm which allowed her access to other depart-
ments, then jumped to new business before becoming
president. Caroline Jones left a big agency for a high-risk–
high-visibility position with a new black-owned ad
agency. Terry Bonaccolta decided to become a car expert
at a time when Detroit thought women decided only the
color of car purchases.

What works against a woman in a corporate environ-
ment? The "invisible barrier" is really a comfort factor,
which can be composed of many things. There is some
sexism to be sure, some men who want groups of people to
whom they can feel superior. But much of it is more
subtle.

Making a promotion decision is based upon all the ob-
jective information available, but a large part of it is gut
feel. You see younger versions of yourself and you know
they'll knock down walls to get to a goal. Or you see
someone with the traits of a good friend. Although they
aren't your traits, you've seen how they motivate your

friend and you know they're equally reliable as a predictor of success.

Women can see these traits in women candidates and feel comfortable in picking them. They've also seen a wide range of successful males, enough to get a good feeling as to which men will be successful. Men, however, have not had much familiarity with women corporate leaders. I think that as a result, when those men see a woman who looks like a good candidate, they don't have that same gut reassurance. They see someone they feel they really don't understand. They have doubts. Top managers have become successful by listening to their doubts.

The differences in management styles already mentioned in this chapter can be another factor in making it hard for men to feel comfortable about women managers. As noted, many women run departments with soft hands on the reins. They ask the advice of the managers who work for them before making big decisions and tend to build a consensus, much like the Japanese management style. Yet, despite healthy sales of books on Japanese management techniques, this can seriously disturb some male managers.

A recent incident brought this home to me rather forcefully. CBS established a new creative department which they wanted the magazines to use instead of our outside agencies. I agreed to switch over our direct mail campaign, but decided to let our ad agency and this new department compete for our print advertising campaign. Each was given the same input, and the ad agency came up with the superior campaign.

My then boss summoned me to his office. He told me the internal creative department said the competition wasn't fair because I hadn't met with them. I told him I hadn't met with the agency either. My boss looked horrified.

Somewhat defensively, I told him that my marketing director was fully informed of what we wanted to accomplish. He'd met several times with the advertising director and me, and I considered it his job to meet with the agency. My boss said, "I would think that's one of the prime functions of a publisher, to meet with the advertising agency and give them the game plan for the next year's advertising."

I told him that I felt it was the marketing director's responsibility until such time as he proved he couldn't do it. For example, the previous year the result hadn't been that good. So I joined the marketing director in meeting with the agency until we got something we all liked. This year the agency produced a real winner on the first try, so there was no need for me to step on the marketing director's toes.

"Well," he said, "that is, of course, one theory of management. . . ." His tone sounded dubious of the value of this theory.

I was really taken aback by the conversation. It was all the more upsetting because this was a very smart boss whose approval I wanted. It was only on my drive home that I could come up with the right words to say. Then, of course, it was too late. But when you write a book you can have the last word, so here's my rebuttal, which also crystallizes the position of several women managers interviewed here:

I believe in letting managers manage. I'm not paying them to be flunkies. If you don't let them run their own show, how will they learn? Furthermore, I think you get better-quality people working for you if you don't ask for their balls when they take the job.

I keep a close eye on what's happening. I make suggestions. If I don't like something an employee is doing, I'll tell him or her. If managers can't convince me their way is

better, then I'll order it done my way. But by giving them the maximum leeway, I get the benefit of ideas they come up with that I wouldn't have. And I'm developing managers for the company who can run things instead of just take orders.

It's still disturbing to me that this could be considered "odd."

10

CREATIVE SELLING TECHNIQUES

(And Client Encounters of the Third Kind)

It's hard to become a president in most industries without some selling experience, and frequently sales is a direct route to the top. In addition, skills learned in selling are applicable to any management position.

Women have been pouring into sales positions in the past ten years, with no slackening off in sight. As an example, in magazine publishing ten years ago sales personnel were 0–25 percent female. Today it's 50–60 percent. Obviously this change is not just a result of women finding out where the power and promotions were. Plumbers make a lot of money, too, but women aren't anywhere near 50 percent of all plumbers.

Women bring some key assets to selling that, according

to many sales managers, make the "average" saleswoman better than the "average" salesman.

Women's childhood socialization usually makes them better able to "read" people—one of the most important sales skills and one almost impossible to teach an adult. According to Mary Kay Ash, chairman of the Board of Mary Kay Cosmetics, "Women are more intuitive. They know when something is wrong."

According to Cathleen Black, publisher of *USA Today,* it's also easier for women to get a first appointment with clients. But, she warns, "You must go in more prepared than a man because you'll be tested. You won't get the benefit of being assumed competent."

I have found that men are likely to be more civil to a saleswoman than a salesman, and less likely to cause a scene or play macho one-upmanship games. This is advantageous in maybe 85 percent of the cases.

For example, when I was relatively new on one magazine, one of my salesmen had been summoned to a client who is renowned in the industry for his sadism. This man liked nothing better than to rake a salesman over the coals and abuse him. The cause of his anger this time was an article in our magazine which dealt with his product area without mentioning his product. (We hadn't mentioned *any* products by name, but he thought as an advertiser he deserved to be singled out.)

My salesman had been through the scene before. He told me to expect insults, threats, and implications about my parentage. I was a "surprise guest" for my salesman, as he wanted to see whether I would throw a monkey wrench in the man's performance. I certainly did. He was surprised, flustered, hesitant, and unsure. We chatted pleasantly for a half hour about the magazine and his product. He offered me sodas, coffee, tea, cookies, and, "Is there *anything* I can get you?" When we left, he stum-

bled in his eagerness to open the door for me. Sadism is a game he apparently plays only with men.

This politeness to women can be a negative if the man won't tell a woman when there's a problem. Some men pretend everything is fine, make nice, and then hide out when a woman finds she didn't get the sale.

Top saleswomen anticipate this and probe hard when they read a false "make nice" behavior. A saleswoman who worked for me said she'll sometimes cause a real scene—"to the point of throwing something across the room and saying, 'You're lying to me.' I want them to get angry enough to break through their conditioning and be honest. It scared me to do it at first, until I realized that a phony 'everything is fine' number meant I wasn't getting the business anyway, so I had nothing to lose." This woman presents an all-American college girl image, which undoubtedly helps her get away with behavior that many other women couldn't.

Shirley Wilkins, president of The Roper Organization, had a client meeting where the man never once looked at her. Even when answering her questions, the man directed his answers to Wilkins's partner. "I'm sure he didn't even realize he was doing it," she said. "I just sent a man to call on him in the future."

Cathie Black was asked for her advice to salespeople. She says the biggest problems come from lack of pre-call planning. "You must have a clear objective. Your presentation must be well thought out—from client benefits not yours—and it should be well rehearsed." Salespeople often miss the benefits of rehearsal. They make the same pitch frequently, and then get a new pitch and walk in cold. Knowing the former pitch does not leave them rehearsed for the new one.

Adds Black, "Another problem is that people don't like rejection. They don't want to hear 'no,' so they stop asking

for the business. If you don't ask, you won't be refused. You will, however, soon be fired."

Mary Kay Ash agrees. "The biggest problem in sales is fear of rejection. Some women can hardly put their finger in the dial. Others can't sell because they don't have the self-discipline. They worry more than they work. If they could only put the emotional energy into calling they put into fear of calling, they would do great."

Ash adds, "It helps them to think of quantity of calls instead of thinking the world will end if any one call is a 'no.' One of our consultants (salespeople) found a wonderful way to quantify the value of calls. She called the stock market and found the price of gold, then she weighed the pink customer tickets we have until she had an ounce of tickets. She called all the customers on that ounce of tickets and then added up all the commissions from the sales she'd just made. She discovered she made more commissions from an ounce of tickets than an ounce of gold was worth. The tickets were more valuable to her."

Ash believes in making those calls as easy for the salesperson as possible. Their standard policy is to call customers two weeks after receiving an order, for service purposes only. They ask if the customer is using the product and if she's happy with it. It gives the customer a feeling of commitment from her Mary Kay representative. It also is a no-pressure call for the salesperson, enabling her to feel like an advisor. They do get some sales from the two-week call, but primarily they get a relationship that makes further sales calls easier.

Salespeople are also encouraged to send birthday cards to customers. Says Ash, "Your birthday is very special to you. It feels good when others remember it."

Ash also emphasizes the importance of giving salespeople something new to talk about. "It's so much easier to

call when you've got a new product or a new idea to promote."

Cathie Black advises, "You have to tailor both your internal and external presentations to your audiences. I gave a presentation to my management once that I thought was just great. Later I heard my boss thought it was too obvious a sales job when it should have been just the facts. I think men can be supersensitive to any appearance of emotion in a woman's presentation. You almost need to do a Sergeant Friday's 'Just the facts, ma'am.' "

Sharon Gist Gilliam, Chicago's budget director, agrees. "Men prefer unemotional, fact-oriented presentations. Emotions feed their prejudices. The best bet is to underplay, like a policeman discussing a mass murderer as 'the alleged perpetrator.' You don't want to be perceived as 'trying hard.' "

In line with that, Gilliam chooses clothes for her presentations that make her look like a banker. "I ask, 'Does this outfit say you can trust this woman with two million dollars?' If not, I don't wear it."

Gilliam advises that you understand what your strengths and weaknesses are. "The budget office," she said, "is always selling something nobody wants—the need to cut spending. Our weakness is that nobody likes our message. Our strength is the bottom line and what it would mean in terms of voter taxes. Also, in selling to a bureaucracy, control of the officially recognized numbers is very helpful."

Louise McNamee, president of Della Femina, Travisano & Partners, disagrees with a "Just the facts, ma'am" presentation. "I know I don't present like most men, but I find it's a benefit in nine out of ten cases. I find people buy for emotional reasons as much as for the facts, even if they don't want to admit it. They buy the person."

Caroline Jones, executive vice president of Mingo-Jones

Advertising, compared sales to an acting company that ad-libs everything from situations given them by the audience. "It's a matter of finesse. When you're presenting creative work to clients, you must be loose. If you're rigid and resent their intrusions and ideas, you're dead. You have to think and adapt on your feet. You also have to take abuse and deflect it. Sometimes it's like being a comedian dealing with an audience heckler."

Shirley Wilkins, president of The Roper Organization, agrees. "You'll frequently find clients wanting to change the parameters they gave you. If it won't hurt the project, I do it even if it doesn't help. They're the client. But if it would hurt the integrity of the project, I have to say no. We're not just selling to clients here, we have a company reputation on the line. We can't compromise that reputation just to please."

How do you handle customers who want to kill you? *Audio* magazine once reviewed a piece of equipment from one of our clients and found the specifications claimed were not met in the equipment. The printed review stated that the product was a very good value at its real specifications, but went on to accuse the company of deliberately falsifying the listed specs in an industry one-upmanship game. It even stated the FTC ought to investigate. The president of that company called to request my appearance (as publisher) at his offices.

It was even worse than it sounds above. The company was part of a prestigious Japanese conglomerate. The loss of face this article would cause the president with his parent company can only be imagined. Additionally, three of their dealers had called to cancel. And the magazine had been out for only three days.

I arrived at 11 A.M., and three people leaped to the attack. They wanted to know why we hadn't called them first. They were sure it was a defective piece of equip-

ment. They wondered if I had any idea how this made them look. Was I accusing them of lying? Did I know they'd put their reputations into this company? That they were honest businessmen, with a good product, and this made them look like crooks?

I explained to them about Church and State. How the editors don't let the publisher see articles before they're in the magazine. How policy is not to check back with the company. After all, the equipment was sent by the company. Didn't they test it before it went out?

I suggested that the president should go after his plant manager or subcontractor, or whomever was responsible for delivering the specifications. I suggested that person may have lied to the president and thus been responsible for this terrible situation. I agreed the crack about the FTC was out of line.

It continued on through lunch. Mostly I just nodded, sympathized, and took it. They weren't really ready to discuss facts yet. They were still in shock and imagining all the horror that could come of this for their company. I kept sympathizing until the three of them started feeling just a little guilty about ganging up on me. They even insisted on paying for the meal.

One week later, we went back to them. We said this episode let them see proof of how our magazine worked. Did they notice how many dealers called up about the article? We told them that to counteract the harm from the equipment review, they needed a campaign to promote themselves to that same audience. We ended up taking a two-page advertiser to twelve pages. We benefited and they soon benefited with increased sales.

Another client problem had an equally beneficial result. We got a call after one issue hit the newsstands. An advertiser had been placed on a page where a bound-in subscription card covered half of his ad. He was refusing

to pay for it. My ad director flew out and told him we had done him a favor by not charging him a premium for the position. We showed him how a magazine that is stapled together automatically opens to the bound-in cards.

We suggested he quickly tie up that position with a twelve-time contract. We told him to check his responses to the ad and see if we weren't right. Sure enough, the responses went up and he contracted exclusively for that position—a position we hadn't been able to give away before. Sometimes a "problem" can be rethought, so a card covering up an ad becomes a card that forces the magazine to open to the ad.

President Nancy Peterson decided to buck standard business practice on one sales call, with happy results for the Peterson Tool Company. At the time, toolmakers automatically gave their designs to manufacturers using their tools. Manufacturers demanded it. Peterson had a new, cost-saving tool her company had developed. She applied for a patent.

At a meeting with a Detroit client, Peterson asked for three years before she had to supply the design. "I told him, 'In order to keep doing research and development, I need to protect my tools long enough to get a patent. It's for your benefit too, as research can result in tools like this that will save you money.'" They settled on one year's protection, plus "patent pending" on all copies of the design after the year.

In sales, nobody is satisfied with the price they're paying. Dealing with that is a part of good selling. Says Wilkins, "We price jobs carefully, knowing we have competitive bids against us. If someone says it's outside his budget, we try to suggest ways to cut back parts of the problem. I tell them, 'I can design you a Cadillac or a Volkswagen. They'll both get you down the street. But you must decide

if a Volkswagen will provide all the results you're looking for.' "

On internal selling, Cathie Black underscored the need to build a consensus. "I once presented an idea to a board of directors, a good idea, and saw it defeated. A woman took me aside and said I should never present a new idea at a meeting—everyone will shoot it down. People feel left out when an idea is developed without them. Now I know to meet first with each individual to sound them out and get their advice. Then they become a part of the idea, so that when it's presented it's their baby as much as it's mine."

If you start your own company, you'll find innovative selling is critical to your success. When Ernesta Procope started E. G. Bowman, an insurance brokerage company, she faced some intimidating problems. Insurance companies will offer the same rates to a company, no matter who is brokering the business, so there was no opportunity to compete on price. Service was the key, but how do you get companies to try you in order to discover the service? Procope felt their minority ownership was the key to being sampled.

"We did a mailing to the chief executive officer, chief financial officer, and the insurance manager of the Fortune 1000 companies. We explained we were a new black-owned insurance brokerage company, gave the credentials of our people, and asked for a very specific, attainable (we thought) goal. We said, 'Don't dump your current brokers, but give us a piece of your business.' We're currently mailing to the Fortune 950 because we now have the other 50 of them as clients."

One risk manager offered E. G. Bowman a difficult piece of business. But he insisted they do it jointly with the incumbent company. "It would never have worked," Procope explains. "The incumbent was one of the biggest

companies in the business. They already had solid relationships with all the potential insurers, and could 'suggest' those insurers write the business only with them. But how could we say no to the arrangement without losing the customer?

"We sat him down and explained you can't be half pregnant," says Procope. "We told him he had the right idea, giving us a piece of the business, but he had to take the whole step. He had to really give us that piece or there was no way we could come through for him. He called us back two days later and took the whole step."

Imogene Forte, president of Incentive Publications, found school supply distributors weren't interested in carrying her creative teachers' aids. "They didn't want to take on a new small company that had a specialized product. We weren't considered important to them."

Blocked out of the traditional routes, Forte decided she had two paths around the suppliers' brick wall: direct mail and consumer demand. She spent scarce money on space ads in teachers' magazines and direct mail, to get sales and to get visibility.

She created demand by giving teaching workshops across the nation. "Teachers have to go to a number of professional development seminars each year," says she, "so I put together presentations on creative teaching."

One successful seminar led to another and soon her reputation snowballed. She got invitations to a lot of cities and attended every one she could. It was her only way to create demand.

She joined trade associations. She exhibited at the national teachers' conferences. Soon enough teachers had been exposed to her product and were demanding more, that she was able to land the distributors who had turned her down previously.

11

PROTECTING YOUR BACK

If you don't own 100 percent of your company's stock, there is no sure-fire way to completely protect your back, but there are a few ways that come close.

Marrying the owner/boss's daughter was pioneered by men centuries ago, but there aren't many women who would be willing to go that far. (Lest you think this method has fallen by the wayside, I just recently had lunch with a very ambitious and talented man who explained casually to me that he'd left his previous job with a family owned company because the boss's two daughters were already married.)

One way of protecting your back, favored by bureaucrats across the country, is to avoid making decisions. Especially in regulated industries, the man at the top is

usually someone who avoided having his name attached to any mistake. The word "man" is used because this does not yet appear to be a good route to the top for women, who are likely to need a solid success or two under their belts.

A frequent embellishment of refusing to make a decision is refusing to put anything in writing. It leaves the maximum flexibility for later denying involvement with a disaster. However, smart employees can take advantage of such a manager for their own purposes.

A saleswoman was ordered by her manager to institute an advertising acceptance policy that would have seriously hampered her sales and thus her commissions. Knowing her boss, she explained her disagreement with the move and then indicated her willingness to do as he wished if he would just put it in writing.

He ranted and threatened, but she said she couldn't possibly take such a serious step without a letter of authorization to do so. He was left with two choices: fire her (and lose a good employee) or let it slide. He chose the latter. He never even considered putting it in writing.

The only reliable way to protect your back is to be a success. It won't prevent knife wounds, but it usually prevents attackers from hitting a vital organ.

"I break a lot of rules," says Dorothy Berry, executive vice president at Integrated Asset Management, "which can be very upsetting to your peers. I come in at 10 A.M. except for an occasional early morning meeting. That's how I function best, coming in late and working late.

"My employees have different rules from the rest of the company. I let them take extra vacation days when business is slow. But when we're pressed for time, they're expected to work weekends and holidays.

"I believe in getting the job done, so when I've needed offices or temps or floaters, I've taken them, despite rules.

To me, the only real rules in business are never to hurt the clients or the corporation, and to get the best possible performance from yourself and your employees.

"Fortunately," Berry concluded, "I've had quick success in each of my last positions, or I would have had to pay dearly for breaking rules."

What Berry has discovered is a widespread corporate double standard: there are bare-bones rules for big successes and there are a vastly greater number of rules for everyone else. Nobody wants to criticize someone who's doubled profits for their division in two years—not peers and not their bosses.

However, if someone who's been protected by his or her success hits a rough patch of any duration, you can expect the wolves to come out from under their sheep's clothing. At that time, a manager who has treated others poorly can expect a substantial portion of those people's time and energy to be devoted to bringing him or her down. Managers who have treated others with respect may feel they're immune. They're not.

Marva Collins, director of the Westside Preparatory School in Chicago, says, "People will find a million ways to undermine you if you haven't become their friends." But being friendly won't protect you from all people.

Says Doris Forest, publisher of *Foreign Affairs*, "Having a big success in front of people is a double-edged sword. I've seen fast-moving managers attract serious resentment from people who weren't moving up. The people left behind either have to believe the fast mover is better than they are (not likely), or that the star had some unfair advantage. Knocking down the star can make them feel better about themselves. If the star is a woman, a rumor about her sleeping with the boss is the easiest one to start. After all, how can she prove it's false?"

Forest adds that there's a limit to how far you can rise in

one company. "Senior people seem to characterize an employee by the job they started with, as in 'Mary, our secretary who made good by becoming a director of corporate affairs.' You can bet against them ever saying, 'Mary, our secretary who made good by becoming President.' " If you start very low on the ladder, you'll probably need to move a couple of times until you're at a company where you started as a department director or a V.P.

Forest also thinks you should expect that male employees will try to go around you to a male peer of yours or try to deal directly with your boss. "I think it's something they feel compelled to at least try. A confrontation on the issue usually solves the problem."

A large part of protecting your back is being well informed, and letting others know you are. Kay Koplovitz is president of USA Network, a nice title in the "glamorous" cable industry and one many others would like.

"You have to expect others to be coming after your job," she says. "It's one of the reasons you need a network of people in your industry who will hear of it and let you know. You have to build a wide assortment of allies.

"Sometimes, you can casually drop a mention to the owners that shows you know what's going on. It gets you credit for being well wired in."

Dr. Donna Shalala, president of Hunter College, agrees. "You need early warning systems, so you'll know what's going to happen in advance and be prepared. I tell my staff part of their job is anticipating. They'll get into trouble if they don't."

If you're always prepared, opponents will learn that "surprise" attacks are seldom surprises and that you are therefore able to highlight any flaws in their attack, making them look foolish. When it becomes risky to attack you, the attacks become fewer and farther apart.

But knowledge may not be enough. Dr. Shalala thinks

that sometimes you must hire "thugs." "They're indispensable for governmental in-fighting," she says. "When someone managed to grab control of a committee that involved one of my issues, I'd make sure a 'thug' of mine—someone with sharp elbows—got on the committee. He'd keep them from running all over our department; he'd make sure that we were consulted and a part of the process."

When asked how you control "thugs," Dr. Shalala says you can't really. "That's why their use is limited." Other than in government, she recommends the hiring of a "thug" to oversee construction projects.

Here are two final ideas for protecting your back in big corporations:

The first involves using the office grapevine to find the boss's "mole." There's almost always one, frequently one who is not easily noticed in the position. At one company, the president had a vice president of finance who reported daily to the president about every single misdeed, no matter how small. But the person could just as easily be in personnel or any department that has dealings across the company.

Frequently this person is semicompetent to incompetent, and it behooves you to not launch a campaign with the boss to have this person fired. You'd be wasting your time and your goodwill. Although attempting to really befriend such a person is futile (your status can't compete with the boss's), you should be on a "friendly" basis. Then, should a competitor launch an attack against you, you have an extra avenue for getting your message across.

Knowing the company snitch can also be advantageous when you want to get a message through to the boss that you shouldn't say in person. I once had a "casual" lunch with such a person. In response to his question on how things were going, I told him they were too good. I was

getting bored, I said. Things were too easy. I thrive on challenges and the challenges were now too small. The only problem, I confessed, is that I really liked the company I was in. It had been good to me, I liked the people, I didn't want to move. I shrugged my shoulders and we moved on to talk of other things.

If I'd had that discussion directly with the president, it would have forced him to officially recognize I was unhappy. Not a good move if he didn't have another opening in mind at the time. This way it was just a bit of gossip for the president to file away in the back of his mind, hopefully to be remembered when he was considering any move that would open something up. (In this case, I had a new position in four months.)

Sometimes the danger comes from former employees who quit and try to hire away all your best people. When I left CBS, the president told me a little story by way of warning me. It was about someone who had left CBS and then hired four people one after the other for his new company. "Take your best buddy," he said. "I don't mind. And someone else you thought was spectacular. But the third person you take, you've got my attention. Forget the fourth. I told this guy we're in a small industry and he should reconsider his actions with regard to his future."

Helen Gurley Brown had an editor who left for the top job on another magazine. She hired away an associate editor, then Brown learned she was interviewing two other editors. "I called her and asked what was going on. I'd done a lot for this woman and I felt she owed me better than that. She said they'd called her; she hadn't contacted them. I said that didn't make much difference in the result for me if they left. She reconsidered and stopped with the one."

Finally, if you're in an industry where ideas and dead-

lines get kicked around in meetings, you might consider a device to help protect your ideas as well as your back.

Caroline Jones, executive vice president of Mingo-Jones Advertising, had a boss who stole ideas all the time. First she got mad. Then she decided to stop him. She started keeping a chronological diary with her at all times. In it she notes every meeting: who is there, assignments, deadlines, and who suggested and who supported which ideas. "It's good because it keeps me organized and keeps me from forgetting things."

When asked about the book, she tells everyone it's her "cover my behind" book. It has had an intimidating effect on people used to playing fast and loose with reality. People who support ideas in meetings and then (when they fail) claim they were against them all along. When she first started it, her idea-stealing boss asked why she needed such a record. "Because people lie," she said.

12

SEX IN THE CORNER OFFICE

A funny thing happens to sexual attractions in the office. They run up against a lust that makes sex pale in comparison—the lust for power. It wasn't too noticeable in the past, because it was a given that the women employees were power-inferior to the male employees. Nobody gets very upset when a boss has an affair with a secretary. It doesn't affect the power structure.

I knew a married boss who promoted his girlfriend from his secretary to office manager. Later, when they split, he started an affair with his new secretary, who eventually made it to personnel director. We all had a lot of fun making comments about it, hypothesizing certain actions.

Again, nobody took it too seriously because it didn't

really affect the power structure. The office manager or the personnel director could give you problems, but they were limited, and she wasn't a competitor for the top jobs.

In fact, what power games *are* played in these cases can be between male bosses, with their lower-level girlfriends serving as the footballs. For example, there was a married male boss who ranked just under the top level of management. He had a girlfriend he'd managed to promote from his secretary into the publicity department.

One day his arch enemy beat him out for the top job. Within a week, his enemy had reduced the size of the publicity department, which just happened to eliminate that woman's job. "Let's see how he takes *that!*" the winner exclaimed to a friend.

Are women bosses adopting this behavior? If not secretaries (there are so few males in the position), are they taking their pick of the mailrooms and the maintenance crews?

I don't know any married women bosses who are having affairs. I'm sure they exist, but I'm equally sure that the higher the level of the woman in the corporation, the less likely she is seeing anyone in the same company.

Single women bosses are very unlikely to date someone dramatically lower on the corporate ladder than they are. This culture still tends to equate a couple's standing— power if you will—with the male's job. A woman boss's authority would be severely threatened by such an internal romance.

It's only marginally less questionable to date such a lower "caste" male when he doesn't work in the same company. Your professional judgment is called into question; however, there can be other benefits.

For example, I once dated a karate teacher. By way of description, when we walked on the streets women would turn their heads to watch him and then crash into poles or

fall off the curb. The first time I appeared with him at the company Christmas party was quite an experience.

He was still parking the car when I met two company executives with their wives at the door. The wives were introduced to me and the atmosphere got decidedly tense and chilly. This was quite a few years ago when women executives were rarer, and they were unsure and suspicious of me.

When my date appeared and I introduced him, I could see their shoulder muscles relax. The women started smiling. They decided I definitely wasn't interested in their husbands, and we later became good friends. It affected the men as well. Two coworkers who had started to become an overly friendly nuisance shifted into strictly business attitudes after the party.

I told my friend he could make a fortune renting himself out for parties.

On the other hand, it changed the way the president viewed me. He started questioning more of my decisions. After all, I guess he reasoned, if I couldn't be trusted to make an "appropriate" decision in my personal life . . . He showed the same attitude to a male manager who attended with a woman who looked and acted like Jayne Mansfield.

So, if women bosses can't date much below them on the corporate ladder without hurting their corporate image, how about affairs up the ladder? How about high-level women managers with their bosses? From what I've seen and from what I've been told by various interviewees, that's about as infrequent as her going with a mail clerk.

For one thing, male bosses really try to avoid it. It even seems to give pause to the company tomcats. If sleeping with your secretary is like playing with matches, sleeping with a high-ranking woman in your own company is like playing with an A-bomb. They know the disruption it

could cause the company, with political fights breaking out (as they did at Bendix). They know they'd be making themselves vulnerable to a woman who, if she turns on him, would know exactly how to nail him. She's also not as likely to be grateful for one afternoon a week (if he's married), or be particularly easy to fire if it all turns sour. In short, she's a bigger potential problem than she could possibly be worth.

Women have their own strong reasons for avoiding it. One is their egos. Women at this level are proud of their accomplishments and are unlikely to do anything to belittle themselves. In this society, if a woman is sleeping with her boss (even if they're married to each other), her abilities and skills are considered questionable. The assumption is that without him she'd never be in such a high position. "You never get any credit of your own, working with your husband," one woman agreed.

Several women I interviewed quit jobs solely because their husbands worked in the same company, owing to exactly that prejudice. Two others work with their husbands in their own companies, but the titles clearly indicate that the woman is the CEO. These women aren't about to throw away what they've worked so hard for.

Another reason it seldom happens is because this society is still sexist enough to imply that women can only sleep their way to the top. Any high-level woman has had to deal with rumors and gossip about herself, and has developed some level of anger or resentment about such assumptions. Another dash of cold water on any embers of interest.

Several years ago, I joined a company working for a jowly, overweight, married boss who would develop tics when nervous. Over time I became friends with a woman who worked for a different department and we would have an occasional lunch. One day I was saying something

about a man I was dating when she got this astonished look on her face.

"You're really *not* sleeping with your boss, are you?" she asked.

It was my first encounter with such an attitude and I was stunned. Not only stunned, but insulted. I was insulted as to my professional judgment as well as insulted about my taste in men.

"You have to expect rumors like that," one of the interviewees told me. "Expect it and be ready for it. I joke about it. I say, 'God, I wish I were; I could be off shopping.' Or I say, 'If I were, do you think I'd be stuck in this job?'"

In fact, only one boss of mine ever even suggested such a thing. This was a long time ago and he was an awkward and insecure man who liked to bluster toughness. He said, "What would you do if I made a pass at you?" I said, "I'd call your wife." End of discussion.

One interviewee had an unpleasant experience that showed her the intertwining of sex and power in the office. She had a mentor at her company who'd advised and guided her as she rose through the company hierarchy, although the advice aspect had diminished over time. She considered it a valuable friendship. There hadn't been even the slightest hint of sexual interest on his part, and there was certainly none on hers.

Then on the day she was promoted to the level just below his own—everything changed. Suddenly he was suggesting dinners and sending flowers to her home. Says she, "He didn't suddenly discover a mad, passionate love for me. I don't think there's anything sexual about his new desire at all.

"My next job here could only be his. He's in no danger of losing his job; the most likely scenario would be for both of us to advance. But I think it is unsettling for him that I'm perceived as being capable of doing the job he was

doing when we first met. He's uncomfortable because our relative power structure has changed. He's no longer so far above me in the company. So I think he'd like to get me back under his thumb in some other way."

She laughed. "When hell freezes over!" she said.

The aspect of office sex that has been a big surprise to me is discovering that men (especially salesmen) will make a pass at women they work for. I should add that these are very carefully worded, oh-so-casual, almost-not-quite-there passes. Masterpieces of subtlety. It reminds me of a moth circling a flame. I'm sure the Freudian explanation would be fascinating.

Two of the single women interviewed also noted it. Neither of them was interested in following up on it. "I've had to make much harder decisions in my career than passing up some man who likes to play with matches," one said. "Good jobs are *much* harder to find than a good date." The other noted, "They always seem a little relieved when they realize there's no way it's going to happen. So why do they try?"

So, if high-level women bosses almost never date down or up the corporate ladder, what's left? The only real action is between managers ranked on similar or almost similar levels. But even that's unusual. There's always this uneasy feeling that you could soon be competing for the same job or—worse—find one of you working for the other.

Most unmarried women interviewed said they had flat policies to date nobody in the same company. And they held to it. It's also a convenient policy, as it enables you to put off an unwanted pass by quoting your policy instead of saying you're just not interested in him.

That backfired on me once, however. I'd frequently lighten up the rejection by joking, "Hey, all you have to do is quit your job. That's not too much to ask, is it?" One

day I used that on a CBS peer of mine who was coming on very strong. Imagine my chagrin not two months later when he left CBS, and called to let me know! Then I had to invent some new tap-dancing steps.

While there are surely exceptions to all this interoffice chastity, almost all women within range of a presidency are gratifying different needs at work. And perhaps because of the great public curiosity about their sex lives, they've learned to keep it as privately compartmentalized as possible. It is the women with a lesser interest in and commitment to advancement who are likely to be involved in interoffice romances.

13

EMPLOYEE INCENTIVES
THAT WORK

Motivating employees consists of offering short-term rewards or threats as well as longer-term carrots. But the biggest trap in motivating employees is in assuming that what motivates you is what will motivate others.

CBS has a school of management for its executives that provided me with some insight into differing motivational hot buttons. I was asked to agree or disagree to statements about the working environment of my department. My employees, in protected blind questionnaires sent directly to the school, were asked to do the same.

My own carrot has always been the opportunity for advancement. I wanted my job to give me independent projects to prove my mettle, and I wanted a boss who was moving up fast. I had structured my department (the busi-

ness office) so that each associate business manager had full responsibility for two publications—and thus the opportunity to shine. And I let them know I didn't plan to be in the job more than two years at the most.

But when I saw the results of what my employees thought about the department, only one person saw a big advancement opportunity. Some of the others had already self-decided they weren't likely to be promoted, even though I thought they were all promotable. Others weren't paying much attention to that aspect of the job.

What they most liked about their jobs was a feeling of *esprit de corps.* They felt our department was single-handedly saving the company a lot of money and that we were a team of valuable consultants to the publishers. The late nights, the crises, the action plans, all served as a powerful bonding element, almost like a company of soldiers under fire. They felt important and needed—and those are, I've learned, great motivating emotions.

Most of the women I interviewed were taking several steps to provide psychic (emotional) as well as material encouragement for their employees.

Doris Forest, publisher of *Foreign Affairs,* tells her new employees they can get her off their backs quickly by showing they can live up to her high standards. "I also give a lot of encouragement and recognition. I try to maintain a collegial atmosphere where people feel their ideas are listened to and valued. Frequently I'll open a bottle of wine for the staff after hours, and they can sit and chat."

As publisher of *Foreign Affairs,* Forest attends "A" list functions. "I'll try to bring staff members along to events that may help them. And I'll see they get to attend advantageous seminars."

Sharon Gist Gilliam, Chicago's budget director, gives her forty employees high visibility with her. "I visit every-

one every day. I'll ask how their lives are, how's the new baby, and how their current projects are coming. We'll brainstorm any problems that have developed. I'll tell them specifically what was so great about their last report. And I'll make suggestions for improvement. Excellent work always gets a handwritten note on the report."

Gilliam finds many women employees need more encouragement than the men. "Women seem to have a greater fear of failure than men."

Mary Kay Ash, chairman of the board of Mary Kay Cosmetics, says vague management is a destroyer of employee motivation. "Women want to know what it takes to get to the next level. So we spell it out, not only in our employee manual, but also in person." The company has "Intender" classes, which meet across the nation and spell out exactly how to reach the next level, what skills will be necessary and how the job will be different. "It not only educates," says Ash, "but it is also a first alert for us that identifies ambitious employees. When you know someone is thinking promotion, it helps you groom her for success."

When Ash meets with employees at any level in the corporation, "I always ask when they're going to make the next higher level."

The biggest motivation for salespeople at Mary Kay Cosmetics is to make the Queen's Court. The country is divided into four regions: diamond, ruby, emerald, and sapphire, and each region has its own Queen's Court. Everyone knows exactly what it takes to get into the Court. If you recruit two reps a month for the year—you're in.

Prizes are known a year in advance. Everyone who makes it gets the basic prize. Past prizes have been diamond rings and mink coats. Then in each of the four regions, additional (bigger) prizes will go to the top three performers. "We don't announce how many recruitments

the Queen produced because in the past, women who missed by one got physically sick," Ash warns. "But we do let everyone know that sometimes (though not usually) it has taken just one or two recruitments over twenty-four to be the Queen."

It's a great system because it's concrete at the first level (if you want a mink coat, you just have to sign up twenty-four reps and it's yours) and has strong incentives to keep working once you hit the twenty-four level.

Terry Bonaccolta, senior vice president at Levine, Huntley, Schmidt and Beaver, believes power is a great motivator. "I delegate authority. I let them make all decisions except the really big ones without even talking to me. And they get to set the agenda at meetings where we discuss the big decisions."

In the same vein, I've found the number of great ideas you get from your staff increases dramatically when they learn they'll get 100 percent credit for them. When I'm discussing new programs and new projects with clerical help on up to the president, I make sure to call it "Joe's plan" or "Mary's plan." Even if the employee isn't there to hear it, you can bet it gets back that the boss is bragging about this great plan they came up with.

"Some employees keep coming to you expecting orders," adds Bonaccolta, "but I put it back on them. I say, 'You tell me how this should go. I'm not sure.' It gets them to delve into their creativity. The lack of orders can be scary at first, but it soon becomes addictive.

"I try to avoid breaking projects into pieces. I assign a project to one person from the first. Then they can develop ownership. It stops being a job and becomes a baby. I get them to decide how to structure it and how to present it to the client. Then I take them to the client and let them do the presentation.

"We have a huge, tedious job that must be done each

year. We do a fact book for each client that runs over six hundred pages, and contains every marketing fact that could be of value to the client. I assign that in its entirety to a different person each year. Everyone teases the person. Before the assignment, they ask who has screwed up badly enough to get the assignment this year. But everyone pitches in to help the person. And when it's done, we have a party to celebrate his or her success."

Bonaccolta believes celebration is extremely important in business. "I look for things to celebrate: projects completed, birthdays, Valentine's Day, everything. When you can create almost a family atmosphere, everyone works harder and better because they don't want to let the rest of the team down. People will always let themselves down before they let their teammates down.

"People want to feel important. I blow up the importance of everyone's accomplishments, and I thank them for the great job. I make sure their accomplishments are noted up the corporate ladder," Bonaccolta says.

"People also want credit for being adults. I had a boss who would pointedly look at his watch when you walked in at 9:30 A.M. If two account executives were talking in the hall, he'd say, 'Don't you two have something to do?'

"I refuse to act like a grade school teacher. When work is slow, I give three-day weekends. I don't mind employees coming in late. But when work is heavy, I expect and I get a lot of overtime."

Bonaccolta believes jokes and laughter are crucial for team spirit. "I tell them my goal is to sit here and eat bonbons. I want them to take over more and more of my job."

She also uses threats to let the staff know how important they are to her. "I threaten their lives or at least their kneecaps if they ever try to leave me." Just recently she learned that one of her managers had interviewed at an-

119

other agency. When he walked into his office the next morning, there was a cane with a big red ribbon on his desk. The card said, "You know what this will be for."

Dr. Donna Shalala was able to give six-month reviews, money, and promotions at HUD, but when she became president of Hunter College, her hands were tied. "I can't fire and I can't control salaries, so I decided to play a game called 'Beat the System.' "

Telephone expenses were running out of control. So Dr. Shalala told all department heads if they underspent their telephone budgets for the year, they could spend the difference on whatever they wanted. Most of them spent it on little items to spruce up their office areas. Things that meant a lot psychologically, but for which funds were never available. Equally important, overbudget telephone expenses virtually disappeared.

"I was able to get ten thousand dollars in motivational money," adds Dr. Shalala. "Passing it around was the greatest incentive of all. For example, I give our security officers a fifty-dollar savings bond for each arrest they make. And I established six five-hundred-dollar yearly awards for the best employees, with the guidelines for winners established by a group of employees from each area. I told that group the first year that what they did with the guidelines would set the tone forever as to the fairness of the awards. They came up with the best guidelines you can imagine."

Dr. Shalala also took a faculty dining room and opened it up to the staff and maintenance crews. "They're an important part of this university and they deserve recognition of that." She attends retirement parties for everyone: elevator men, cleaners, teachers, secretaries, et al. She also established full-scale employee counseling.

Marva Collins, director of the Westside Preparatory School in Chicago, says adults and children both want

respect and want to be rewarded. "I treat people as I would want to be treated. People learn by your example. A poor performance is an indication you haven't been explicit about the job requirements."

Collins believes small things have big effects. When she travels, she brings back small gifts for the staff who couldn't join her. And she's been known to take all her staff members to an important show. Christmas means a personal letter.

"Nobody should be taken for granted," Collins asserts. "When we get a school lunch, I always thank the cook. When my secretary brings in something, I thank her. When someone does something extra, I notice it and thank them. Sometimes I see someone doing much better work and I give them a raise on the spot."

Collins believes these principles are common sense and apply equally well at work and at home. "My husband says, 'You know I love you.' I say, 'No, I don't. I know you did yesterday. Today might be different. I only know what you tell me.'

"A big ego distances you from your staff," she adds. "The bigger the ego, the more flamboyant the actions, the quicker your clients start disappearing and your coworkers stop helping. When I get some Harvard graduate who thinks he's hot stuff, I just let him loose in the classroom. He quickly learns you give respect or you don't get it."

"I let the staff see me mop floors. I'll clean up a child who's soiled himself. There's no job here I haven't done and won't still do. I'll pitch in and cook. I had a teacher say, 'I don't wash dishes even at home.' I told her, 'Neither do I, but I do it here.' I don't lecture, I just provide the example."

Collins calls her janitor Mr. Holmes. "People deserve your respect. And I'll praise a good job." Collins will remark that the floors have never shone so brightly, that the

food is especially good today, and that the new partition is perfect.

She also keeps her eye on the importance of the client. "My father was a small businessman. I learned the importance of pampering your best customers. We have some parents who really extend themselves in fundraising and in volunteering and I believe in showing our gratitude. I tell my staff, 'Those people are paying your salaries and keeping this roof over our heads.'"

Helen Gurley Brown, editor-in-chief of *Cosmopolitan,* hasn't had to hire a new editorial person in ten years. In fact, her success in keeping her employees is so great that she's considering a new position just to shake things up and keep everyone from becoming complacent. How does she keep her staff?

"Everyone likes to work on a winner," she reports, "so the success of *Cosmopolitan* is a great help. Plus we have a nice atmosphere here. We pay very well. We have no dress code. My senior editors don't get in until 10 A.M., when I do, although we work until 6 or 7 P.M."

"And there's also no animosity. I just can't stand to have people mad at me. So if I've done anything, been short-tempered, I'll apologize quickly. When I get angry I try to stay away from the person until I have it under control. For example, if someone sent a writer to another city for a story, which is completely against our policy, instead of killing her I would write a note. I'd probably ask, 'Is there some mistake here?'

"I also give our senior editors their own power base. Each has a clearly defined area of responsibility. But there is also an opportunity for them to assign writers according to their interests. About 90 percent of our article ideas are thought up by the staff. I okay them and then the ideas go into books for assignment. There are four books based upon four types of articles needed. If an editor wants to

assign a particular writer, she can find a topic in the books and assign it.

"We also have a Bachelor of the Month column. Our senior editors can take bachelors out to lunch, say at the Russian Tea Room, to see if they would be good for the column. I think they should be able to use their job to enhance their social lives."

It's interesting to note that while the women interviewed do make use of traditional incentives—raises, bonuses and promotion opportunities—they also place a great deal of importance on "soft" incentives. In particular, they go out of their way to recognize good work. For example, let's look at an employee given a project that will take six months to complete. Most bosses would praise a good job at the end of the project. These women are finding interim steps along the project where praise may also be given.

Mary Kay Cosmetics, in particular, used to be laughed at by the business establishment for the amount of praise they give good employees. Having them appear on stage. Applauding them. Then, as the success of Mary Kay became evident, it was explained away as incentives that work on women (because they're more emotional) but would never work on men.

Some smart male company presidents decided that all humans, regardless of sex, like to see their accomplishments recognized. These men instituted company-wide recognition programs that rewarded good work by every level of employee. When Tom Peters and Robert Waterman Jr. started investigating the best-run companies in America, several of these men found their companies in the resulting book, *In Search of Excellence*.

In operant conditioning studies, psychology students learn you can motivate rats to run mazes in two different ways: You can reward "good" behavior, or you can punish

"bad" behavior. Similarly, managers can try to motivate employees through rewards and praise or through fear.

Psychology students quickly learned the superiority of the "reward" method. Rats trained by pain avoidance did run the maze, but never as quickly as those trained by rewards. And pain-trained rats were never eager to get to the maze. Similarly, bosses who rule through fear get results, but never get employees who work quickly and eagerly, who voluntarily come in early or stay late, and who wake up at night thinking about solutions to work puzzles.

There was a psychology study that asked employees to rank all their workmates as to ability. Then each was asked to rank him or herself. They discovered that even those employees ranked in the bottom one-fourth of the group by their peers ranked themselves in the top one-fourth.

Now, imagine what happens when an employee who thinks he's in the top one-fourth of his workmates gets feedback from his boss that he's no good. Does he accept it? Decide his performance is bad so he'd better improve? Not at all. He *knows* his performance is in the top one-fourth. So his boss must have a personal grudge against him. *It's unfair. The boss is a jerk. Why knock myself out? The boss won't recognize my good work.* Thus the employee's work gets worse.

What happens when this same employee is rewarded for something he did well? *It's about time somebody recognized my work. Hey, the boss knows. This'll show Eddie that he's not the only big deal around here.* It feels good. The likelihood is that the employee will start taking actions to get more of this same good feeling. Thus the work improves.

Each of the women interviewed has pulled together several means of rewarding and praising good performances, thus reinforcing a positive image in their employees, and thus resulting in a far more productive staff.

14

(RE)MOTIVATING PROBLEM EMPLOYEES

"Everyone wants perfect employees," says Marva Collins, teacher and director of the Westside Preparatory School in Chicago. "But they don't exist. Plato said perfection is just an image which cannot be found in reality."

"If you have a problem employee," says Cathie Black, publisher of *USA Today*, "and you give him a lot of work and help, at the end of a year you'll still have a problem employee. Meanwhile you've invested a lot of time and energy that could have been better spent."

"People who give up on motivating people are just lazy," says Collins.

Actually the range on the question isn't as far apart as it

seems. Marva Collins's job is motivating people, particularly people everyone else has given up on. Cathie Black's job is taking a national newspaper that cynics said would never turn a profit and making it a success for Gannett—a job everyone now agrees she will accomplish. All bosses find themselves in a gray area as they try to decide which employees could be improved and how much effort is cost-effective to put in before throwing in the towel and firing the person.

"Everyone who works for you is a problem at some time," says Dorothy Berry, executive vice president of Integrated Asset Management. "When you're deciding if someone's capable of improving, you'll find their work ethic is the biggest key."

Explains Berry, "I inherited a man as an employee who just couldn't deal with the corporate environment. He was belligerent and arrogant. I wanted to fire him the first day. But no one else was quickly available. On the plus side, he was very conscientious, although a perfectionist and overly sensitive. He had a strong work ethic.

"I decided to take a risk with him. I said, 'Look, we'll probably never like each other, but I need this department to run smoothly. I'll put you in charge of it and stay out of your hair. Can you do it?'

"He turned out great. Oh, he'll never be good in a meeting and I need to shield him from the upper bureaucracy, but he's running his department smoothly and efficiently. Sometimes people need successes to bring out their best."

Shirley Wilkins, president of The Roper Organization, had a male employee whose male boss thought he should be fired. "He couldn't do anything right. I wasn't convinced, so I transferred the employee to another department. Now the employee is doing great. So is his former boss. Sometimes you have serious chemistry clashes."

Ernesta Procope, president of E. G. Bowman, had an employee who wasn't fitting in. "She was very smart, but she was a nine-to-fiver. She stayed apart emotionally, you could see she didn't feel she was a part of any team."

Solution? Procope promoted her to assistant vice president and gave her a department to run. "She really jumped on the opportunity. She's a great manager and her department is humming. Her problem was she wasn't challenged enough before."

Selamawit (Sally) Bissrat, general manager of the Tarrytown Hilton, was able to save one of two problem employees.

One was a secretary who wanted to move out of secretarial work. "I started working with her, but got nowhere and eventually had to let her go. I saw no sense of responsibility. She'd come in late. She'd be careless with her work. She said she'd do better if she wasn't doing secretarial work, but I didn't buy it. Conscientiousness and responsibility aren't job-specific. She just didn't have enough desire to build any fire under her."

The other problem was a man in his late twenties who held a part-time clerical job. There were a lot of complaints about him because he refused to work any overtime. If he was in the middle of a project and five o'clock arrived, he would drop it and be out the door.

It wasn't due to poor work ethics, however, but a lack of attention. He wanted to be a writer and was attending classes. His attention was on writing and he scarcely noticed his work.

"I didn't like seeing such a bright man go to waste," said Bissrat. She decided to give him more challenging work and to tease him out of his blindness to the job.

"I'd say, 'I know you *never* work overtime, but I have this project that isn't quite as boring as what you've been doing and I'd really like you to handle it. Would you do it

for me?' He'd smile and comply. Soon he started paying attention. Pretty soon he was doing more and more and getting involved. Today he's director of sales for a hotel, loves it, and gives me the credit for opening his eyes."

Marva Collins's Westside Preparatory School takes inner-city children labeled "unteachable" by Chicago's school system and soon has them discussing the merits of Plato and Aristotle. Nobody can claim more success in motivating "problem" students.

Says Collins, "I never use the word 'wrong.' I say instead they're 'unique.' I also tell students, 'You're far too bright to do that.' And whenever I reprimand anyone, including teachers, I place a hand on his or her shoulder. It reminds them we're in this together instead of separating us into opposing sides."

Collins applies the same principles to motivating employees. "I'm very frank, but I don't believe in writing memos—again it distances you from the employee. I talk in person. I've told employees, 'Do you realize I wouldn't take this trouble with you if I didn't think you were good? It would be much easier to fire you.' I also tell my staff I want them to be able to work successfully anywhere."

Collins had an employee who was very messy, leaving a jumbled desk where it was an eyesore. "I embarrassed her by cleaning her desk for her. Once was all it took."

Another secretary found her files being organized by Collins. It's embarrassing when the head of the company is seen doing your job.

Another employee used to be late with the most pathetic excuses. "My shoe heel broke and I had to get it fixed." "My dog ran away and I had to find him." Collins told her even if the excuses were true, she shouldn't give them. "You need to have more pride in yourself as a professional than to tell someone such a tale about yourself."

Others have dealt with the problem of once-good em-

ployees who turn stale. Says Mary Kay Ash, chairman of the board of Mary Kay Cosmetics, "When a good employee suddenly slips in performance, check first for some problem in his or her marriage or a serious illness. Those problems, at least, can be overcome in time. If it's something else, more direct steps will have to be taken."

Ash had a consultant who had been excellent; then slowly her enthusiasm ebbed, her sales started dropping, and she eventually stopped coming to sales meetings. Talking with the woman's boss, they decided the problem was in bookings—she wasn't getting enough. So they asked her to address the next sales meeting on how to initiate and follow through with bookings. They wanted her to teach others the subject.

"In preparing the talk," says Ash, "she went over all the rules and tips she had forgotten, and helped herself in the process of helping others. She convinced herself she could do it again. It's good to let someone whose interest has waned pick a subject she's done well before. Let her come in and relive those moments of success. Let her remotivate herself from remembering what she's done in the past."

According to Sharon Gist Gilliam, Chicago's budget director, "Human nature doesn't change; or at least *you* can't change anyone. A once-good employee has a better chance of being good again than a never-good employee has of becoming good." Gilliam tries shifting them to a new area. "Sometimes they just need a new challenge, new routines, new problems to spark back up."

15

UNDER SIEGE

(Crisis Management from the Bunkers)

Management usually consists of small decisions which cumulatively help or harm the company, but there are occasional big moments when the fate of your career or your business is on the line. When all the military analogies suddenly seem more accurate than you would have believed possible.

A crisis confronted and overcome leaves a satisfactory confidence in your gut, confidence that carries you well into the future and makes the little daily problems of business less distracting—and strangely (or not so strangely) leaves you almost wishing for a new crisis to face and overcome.

That, of course, is after it's over and you're successful. In the middle of the battle it's a different story.

Carolyn Wall had left a job as publisher of *Ad Week,* an industry publication for the advertising business, and started as associate publisher of *New York* magazine. Although there were no guarantees, the "publisher" slot was vacant and obviously a carrot.

Two weeks into the job, she received a call at home at 9 P.M. It was one of her salespeople, calling to let her know that three of her best salespeople were going to hand in their resignations the next morning. They'd agreed to go work for her predecessor at his new job, and they were going to be paid a lot more money.

"I went downstairs, got in my car, and drove around the block three times, reeling," remembers Wall. "Then I went back to my apartment and called my boss. And then I called each of the three. I told them I really thought they should talk to me and I set up breakfasts with each of them individually, starting at 6 A.M."

Wall had some tangibles she could offer, but she couldn't match the money. Instead she focused on intangibles. She told them if they went back to her predecessor (for whom they had long worked and who was a personal friend) they wouldn't grow. They would always need that umbilical cord. They would be confident only in his environment. She told them they needed to experience new environments in order to grow and in order to be a success in their own right instead of a success carefully tucked under his wing.

"I hardly stopped talking for eight days as they considered and reconsidered. At one point my boss said there are a lot of good salespeople in town and maybe we should forget these and get some others. We could have, but this had become something bigger than specific people.

"Nobody ever tries to take three people at once from the same magazine. It was an obvious attack and it carried an obvious implication that I was too weak to stop it. I was

new. My credibility was on the line. All our other sales-people were just watching to see who would win."

Wall's face started a small smile.

"Well?" I wanted to know.

"All three of them stayed. You know, I was just so deter-mined. I think I won by sheer willpower."

A week later, at an industry event, an industry pub-lisher stopped at her side. "I hear you're a real pushover," he said. They both smiled.

A few months later, Wall was named publisher.

Lillian Katz, founder and president of Lillian Vernon, faced a different kind of crisis, a crisis born of success.

Lillian Vernon revenues had grown 500 percent in five years. Katz had discovered the Far East and found a wealth of products. The catalog became more interesting and the orders piled in. But the back office hadn't been able to keep up. She didn't have enough experienced people in place and the computer systems were straining under the load.

The 1983 Christmas bust was an unwelcome surprise. Catalog companies everywhere were reeling. It was a crisis, but one Katz welcomed as a chance to tighten up some company flab.

"I recognized that growth isn't the answer in business; it's the bottom line. So we initiated some tough steps." They stopped a lot of direct marketing, canceled the mid-night-to-8 A.M. shift and closed the buildings at night, canceled 800 numbers, and made serious staff cuts.

"We got a management survey and took some of the suggestions. We reduced our bank obligations. Then we faced the biggest problems, convincing the remaining employees that the cuts were over."

Katz met with the marketing group and told them they were the people she needed to run this business. She gave them a target of cutting $1 million from the advertising

budget. Similar meetings were held with the other departments.

"I don't believe in making several cuts over time," says Katz. "We analyzed the company, made our decisions, and made the cuts. And while it took a little time, the remaining employees started believing and stopped worrying about their jobs."

The moves were a big success, resulting in a leaner, more profit-oriented company. Katz discovered that employees let go in a tightening up were employees that shouldn't have been hired in the first place.

In 1985, Lillian Vernon made a profit in the first half of the year—something very unusual for a mail order business.

I faced a crisis on *Sportswoman* magazine in 1974. I had sold it for money to be received over a payout period of five years and a contract as editor for two years. But only months into the arrangement I began to realize it wouldn't work out.

While the new owner had two other magazines, they apparently weren't doing anything for his cash flow. I still had the mail coming into my post office box in California, while the new owner lived in Chicago. I'd ship him a batch of checks every week, but soon he was asking for them twice a week.

I was supposed to transfer the address to Chicago, but I stalled. Even then I must have realized possession is nine tenths of the law. I had started getting calls from angry suppliers who hadn't been paid. I sat down and went over our sale contract very, very carefully.

Buried in the verbiage was a phrase that the new owner was to "pay the bills as they become due." Obviously, he wasn't doing that. Equally obvious, it was something you could squabble about in court for years. But I had "possession" of the cash flow and orders.

I sent him a registered letter advising him he was in default of the contract and I was therefore reclaiming the magazine. I opened a bank account and started depositing the checks myself. The finances were in terrible shape and I knew I'd either need to raise outside money to continue or sell again.

Knowing I had the upper hand, the man could only write threatening letters in order to receive a cash settlement for my taking the magazine back. A lawsuit would have cost him cash he didn't have. We did come to terms, finally, that left me free and clear to sell it again. This time I demanded—and got—all cash. All up front.

Not many presidents have had to face a crisis like the one faced by Ernesta Procope, founder of E. G. Bowman Company. She awoke one morning to find a newspaper claiming her company had bilked the city of New York out of $1.3 million; her biggest contract was canceled and her company blacklisted from doing further business with New York. Knowing the charges were false couldn't have been much reassurance. The challenge was to keep the company alive long enough to prove the charges wrong.

Bowman-Procope, a subsidiary of E. G. Bowman, brokered the worker compensation and liability coverage for New York's Human Resources Administration (HRA) with the Hartford Insurance Group. But in September 1975, Hartford told Bowman-Procope it would not continue the coverage unless it received a 300 percent premium increase. Bowman-Procope had twenty-five days to find another carrier.

A city tottering on the brink of bankruptcy (as New York was) did not seem a good bet to insurance companies. Cosmopolitan, a company rated mediocre by insurance reporting firms, was the only company interested at a premium the city could afford.

Within two months, Cosmopolitan wanted out of the

three-year contract. HRA wasn't paying premiums on time and wasn't maintaining decent records. Bowman-Procope would have liked to move HRA elsewhere, but there were no takers. Bowman-Procope continued the search until 1980, when they were able to move HRA to the American International Group.

By 1980, Cosmopolitan's problems were so severe the New York State Insurance Department had to take it over. After two months, they decided to close it and turned it over to the Liquidation Bureau.

In November 1982, the Department of Investigation (DOI) accused Bowman-Procope of negligence in concealing approximately $1,360,000 in return premiums due HRA, improperly retaining $50,000 due HRA, fraud, and mishandling of its contract. It also barred them from doing further business with New York.

Convicted in the media, unable to get an exact reporting of what the DOI was basing its charges on, facing a lengthy period of investigation and response, E. G. Bowman's survival was on the line. Sixteen employees had to be laid off.

Procope immediately contacted their other clients, assured them the charges were false, and asked for their support during the time it would take to prove the charges wrong. In what can be a skittish industry, she didn't lose a client. In fact, they developed a new church insurance category of business, and today are the insurance brokers for over 175 churches. Her clients were betting on her integrity.

On February 1, 1984, over a year later, the investigation commissioner reversed the findings of his staff. It was the only time that had happened in seven hundred cases. The commissioner admitted there was no evidence of dishonesty on the part of Bowman-Procope or its principals.

The $1.3 million was a calculation of potential returns that could not be filed for prior to the charges being made. The $50,000 was a "rainy day" account which HRA's Director of Insurance had asked Bowman-Procope to establish, and which Bowman-Procope advised was essential in the city's financial crisis.

"Imagine," said Bowman-Procope in its rebuttal to the charges, "no coverage in the heart of Harlem or Bedford Stuyvesant because the city failed to pay premiums for its employees' fringe benefits coverage, workers' comp, general liability, and fire insurance. The riots of the sixties would have been child's play had catastrophes occurred because of nonpayment of insurance premiums by the city and subsequent cancellation."

In fact, when Bowman-Procope first started working for HRA, they had uncovered $500,000 in premium refunds due from the previous carrier. The city had sent them a letter of thanks for the money in 1974. In 1982 it attacked them and in 1984 it admitted its mistake and removed their name from firms barred from doing business with the city. Not much in the way of recompense.

Nancy Peterson also ran the risk of losing her company —in her case because of the death of her husband. She found an ingenious solution.

Peterson's husband had started Peterson Tool Company in 1959 with a $500 loan. Twenty years later, the Nashville, Tennessee, company was custom designing and manufacturing cutting tools used in the machining process for over a thousand companies. Mrs. Peterson saw her main role as raising their six children, but she had helped out at the company in several functions over the years— payroll, reception, bookkeeping, purchasing, etc. As the children grew, so did her involvement with the company. By 1979 she was vice president.

But in 1979, she learned her husband had cancer. He died five weeks after its discovery.

"I knew we were in a very skittish industry," she said. "You could shut down production lines if you didn't deliver on time to our mostly out-of-state customers. I knew they wouldn't risk their businesses on a woman when they could easily go elsewhere. And if they pulled out, it was the end of the company, the security John had built for our children and a lot of needed jobs in Nashville.

"I knew I had to hide John's death. I figured if I could keep it up for six months, I would have established a track record. I could say, 'I've been running the company for six months and you haven't noticed any difference.' I knew it was my only chance."

Peterson was aware that there were three employees critical to the continued success of the company. They were the only three let in on her plan. "I let them know how much I needed their help to keep the company running. And I offered them each lifetime contracts that made it very clear how much I valued them. I protected the company with keyman insurance on each of them.

"I knew they needed me to be strong at this time, so I didn't let them see me crying. We had already developed a degree of trust in our dealings. For example, I had often learned of small things in the plant that I hadn't passed on to John. They had noticed it and as a result dealt with me as an individual instead of just as John's wife."

She was helped by the secretive habits her husband had established. When he was on vacation, only his trusted secretary knew, because he believed employees play when they know the boss is playing. This left employees and clients assuming he was out of town on business.

"I wasn't dishonest with clients. I just passed their calls to the appropriate person to handle it, as though my husband were out of the office.

"When I told the clients, showed them our lifetime contracts with our key employees, and reminded them of our excellent performance in the past six months, I didn't lose a one of them. There *were* some shocked expressions, however."

There's really no way to prepare for a crisis, but when one comes, you'll have a better chance of overcoming it if you're already running a smoothly efficient business with highly motivated, loyal employees. Early warning systems, and a high value on keeping an ear to the ground, can sometimes give you more time to avert or at least deflect crises.

When all hell breaks loose and you're in serious danger, you discover a lot about your character—usually that you're much tougher than you thought. When you refuse to run for cover and hide, when you realize that clients and employees are willing to trust you, when you find paths to corporate safety where others see only booby traps—you're facing down the specter of failure. And you're developing a wonderful cushion of self-confidence.

16

CORPORATE LADDER CLIMBING

———————————⟫⟨———————————

Getting promoted, either internally or externally, is largely a matter of high visibility, gaining allies, picking a small group of targets on which to concentrate your efforts, and knowing when to push. There is also a luck factor, but maximizing all the other factors makes a person "luckier" than others.

High visibility is always important in your industry, but it is also important within the large corporation. In pushing for high visibility, be wary of the downside—looking overly eager or overly impressed with yourself. Remember that linemen don't block for self-impressed quarterbacks or running backs. Superstars have an ability to laugh at themselves and attribute all their successes to their teammates—while at the same time maximizing

their own visibility. It is this skill that is seen in top corporate leaders.

Dr. Donna Shalala, president of Hunter College, operates on the "Multiple List Strategy." This theory claims that the more people's lists you pop up on as a potential candidate, the more likely you are to get the job. She advises it is particularly helpful in getting a government job.

While teaching at Columbia University, Dr. Shalala got herself involved in committees trying to prevent New York City's bankruptcy. That exposed her to a wide group of local politicians. That plus her academic credentials helped get her a job with HUD in the Carter Administration. When Hunter College was looking for a president, Dr. Shalala's name kept coming up in academic circles, local government, and Washington, D.C. She also sits on twenty boards, which provides exposure to another large group of prominent people.

"Visibility" is defined here as the result of working with a large, diverse group of influential people. It is not a matter of getting your picture in the papers—the kind of visibility most likely to cause a backlash. If visibility in your industry does require press visibility, it is best gained as head of a committee or while presenting a paper instead of merely attending a function. And be prepared with a couple of jokes to show you don't take it seriously.

Visibility with influential people can also be a tactic in a large corporation. I lucked into it myself at CBS. When I first arrived, there were three subgroups of magazines: the men's group, the women's group, and the special interest group. I joined the special interest group, in a job that brought me into contact with all the finance departments. Then I moved to acquisitions, where I worked with several top managers in the men's and the women's

groups, plus several top managers in circulation, production, promotion, etc.

By the time I landed at *Audio,* I'd worked with most of the managers in most of the departments. In fact, the man who hired me at *Audio* said he was delighted that so many different people in different departments told him it was a great idea. By contrast, some talented people I met when I first started at CBS have stayed within the same group or even the same magazine for the past seven years. I think it's hurt them, because fewer people have been exposed to their talents and abilities.

Louise McNamee, president of Della Femina, Travisano & Partners, got the same wide exposure by inventing jobs for herself that interacted with several departments.

Hired into an agency as a normal researcher, she noticed a budding interest in motivational research and started making herself its guru. Motivational research has a natural bridge with the creative department, which she maximized.

"Many research departments are jealously guarded turf," she explained. "They use the biggest words possible to increase the need of researchers as translators. But I translated research terminology into easily understood words. I was extremely accessible. I asked for advice and help from the business side as well as creative, and would return to them with results that would be of interest to them. Thus I built support in both areas."

Soon her work was so well received, and of interest to so many other departments, that a new department needed to be put together, formalizing what she had been doing. Not pure research, but research to help creative. McNamee now had a department to head.

Her cross-department expertise allowed her to talk her way into a job bringing in new business. This job increased her access and visibility to several agency departments.

And it gave her a final important skill in her portfolio. Almost nobody makes it to the top without demonstrating they can bring in new dollars to a corporation.

Terry Bonaccolta, senior vice president for Levine, Huntley, Schmidt and Beaver, found increased visibility by selecting an industry where a woman was most unexpected. When she joined Doyle Dane Bernbach, it was 1969 and they weren't hiring women executives. She joined with the promise of her boss to fight management for her if she was successful.

"I was working to 10 P.M. every night and was making myself indispensable to others, but I worried it wasn't enough. I decided I didn't want to be another lipstick lady. Instead I decided to become a car expert." When Bonaccolta came to Subaru, it was billing $11 million. It's now billing $48 million, and her agency has eight of the fourteen independent Subaru distributors as well.

Caroline Jones, vice president of Mingo-Jones, went for "visibility" in a literal sense. Hired by a big agency, she was told there were temporarily no cubicles next to her boss's area so she should take one down the hall until the offices were rearranged. Jones refused, and grabbed an abandoned secretary's desk in the middle of the hallway, just across from her boss's office.

The temporary office crunch continued for a full year before space was rearranged (expect this in large corporations). All during that year pressure was brought to bear on her to move into an office and out of the hall. It disturbs a corporation when someone rejects the facilities appropriate to his or her level.

"It was important to me to be near the boss," says Jones, "because she would informally talk business to the staff and I wanted to make sure I was in on those talks." One year later, when new, better offices were designed, Jones got one of the best for her level. (P.S. It was near the boss!)

When Jones left that agency for a small, black agency start-up, visibility was one of the reasons. "We were big news at the time," she said. "We were featured on "60 Minutes" and in *Time* magazine. This visibility got us in to the top people at the clients, which made high-level contacts for me I would never have gotten trying to move up the ranks where I was."

If you're looking for a job outside your company, it usually works best to target in on two or three companies you would like to work for and prepare yourself. Learn all you can about the company and the people you would be working for or with. Give a lot of thought to that department (or company)'s problems and what you could bring to them. Then start pushing.

Sylvia Porter instinctively knew the benefits of targeting a job and refusing to give up. Porter was determined to carve a career for herself in the financial community— at a time when women were rarely considered qualified to be a secretary in the industry!

"I saw a tombstone ad for the opening of a financial firm," she remembers. "When I got to the company I asked them if they had an opening for an assistant. 'Yes,' they said, 'but what are you doing here?' I told them I wanted the job. They wanted to know what I could do. 'I can do *anything*,' I told them. I think they hired me because they could read in my determination a person who would do the work of two or three."

Porter's next target was a writing job at the New York *Post*, a much more difficult proposition.

"Every day I would leave work early enough to be at the New York *Post* by 4:45 P.M. I would find the editor, who was always drunk by that hour, and ask him for a job writing about finance. Every day he would tell me no. He asked why I kept coming in and bothering him. Still, I kept coming for six months."

147

One day he seemed extra drunk and said to Porter, "Someone ought to reward persistence. You're hired. Write me something now."

She sat down and wrote a column on the spot. If it hadn't been good enough, he would have fired her as quickly as he'd hired her. As it was, he made her use her initials instead of her female-revealing first name, but she was suddenly a columnist.

Identifying internal targets can be a little trickier. One technique is to identify a new area that could bring the company new business and promote yourself as its head. This is what Louise McNamee did when she turned the new discipline of motivational research into a department. You could talk a magazine company into setting up a department selling merchandise through the magazines. You could talk a manufacturer into setting up a mail order arm. If you can show opportunity for new profits for the company, you're halfway there.

If the job you'd really like is your boss's, you'd best be looking for something else at the same time, unless you know she or he will be quitting in the near future. Don't pin your hopes on a bad boss being fired.

Another option is to target positions that are likely to open up in the near future. This works well if your company has several profit centers, for example, a manufacturer who has different product managers handling each of its products. If one of the product managers is performing poorly and sales are dropping precariously, that is a position that is likely to become open. But it won't become open until management has decided who they want to fill it. Be ready to tell them what you would do differently.

The third critical element in getting promotions is timing. You must push from a position of strength. When you have just achieved something important—you've had a

record-breaking month or year, guided your department to the best improvement record in the company, took a money-losing property and made it profitable, landed new accounts worth a lot of money to the company—this is when you go to your boss. If your boss is not the one who can hire you for the position you want, you must still make that your first stop. You must let your boss know how great it has been working there, how much you've learned, how lucky the company is to have someone who can develop talent for the company, how excited you are about the possibilities for the position you want, and how much you want his or her advice on how best to present your ideas to the person who would hire you.

You must have developed someone in your department who can move into your current position, or management will never promote you. Says Shirley Wilkins, president of The Roper Organization, "The better you can train someone on the next rung down to do your job, the freer you are to move up."

Where corporate job descriptions aren't rigid, you can move up by adding work to your department. Wilkins claims every promotion she got was the result of her already doing the work. While responsible for research, "I gradually assumed more and more responsibility for the administration of the company. First I got into finance, then personnel, then policy. Once people realize you're doing the work, the title comes."

The Roper Organization had been structured as a partnership, with Wilkins one of the four partners. When they incorporated, Bud Roper became president and Wilkins became a vice president.

One day a call came in from an association, which Wilkins spearheaded into a specific research project. Roper and Wilkins arrived to present the project to the board of presidents heading up the association. Roper introduced

Wilkins as his partner, but several times during the meeting the association members referred to "Mr. Roper and his assistant Shirley."

It was only the last straw in a series of similar incidents. Roper was angry at the refusal of clients to recognize Wilkins's status and importance to the company. So he kicked himself upstairs to chairman and made Wilkins president. He said it was just another case of her doing the work already so she might as well have the title.

Dorothy Berry, executive vice president of Integrated Asset Management, also got her promotions after she'd been doing the work.

"Titles don't matter to me," she says. "I want the responsibility and the money. After that, the title's nice but not necessary. Some companies give women titles as a sop, without the power base or the money. Internally, everyone knows who's got the responsibility, and you can make it known in your industry as well."

How do you put the pressure on your company to take the step and promote you (assuming the timing is perfect and you've just scored a smashing success)?

If you're in a low-level position and have been stymied, you can try just about anything. Caroline Jones had been marching into her boss's office twice a year demanding the writing position he'd held out as a carrot. After a year, she pushed very hard and he admitted he couldn't do anything. She asked who could, walked into the man's office, showed writing samples, said she would have to quit otherwise, and (operating on instinct) broke down and cried. She got the job.

For high-level jobs, pressure comes from the implied (almost never stated) threat of leaving, sugar-coated with why you can make the company more profitable. When talking about your excitement for the opportunities you see with the new position and your eagerness to get

started, you are by default indicating your dissatisfaction if you were to be stuck in your current position—which you have so obviously outgrown.

Push as hard as you can without seriously angering the person. Two or three months down the road your success will shine dimmer in corporate minds and your chances will be worse. If they absolutely don't feel they can make the change you want, move to choice B. Or let them suggest a problem area they have been considering changing. Push for it from enthusiasm for the opportunities, not from a feeling you "deserve" it. Enthusiasm sells.

What should you do if you're just one of the contenders for the promotion? Don't be seen to start playing politics. It undermines your perception of strength. It's the time to be a statesman and speak well of the company.

Dorothy Berry found herself one of three people in contention for president a few years back. The other two candidates were men. Berry thinks they felt a lot of pressure at competing against a woman, because both of them overreacted and blew themselves out of the water. She didn't have to do a thing.

One of the men started dropping little hints to the chairman about all the mistakes of the other two candidates. The chairman would mention in a meeting with Berry that her competitor (he named him) said "X" about her. Berry would consider it, then say, "Well, I don't believe he's considered 'Y.'" She didn't get defensive or sling mud back. That contender was soon seen as negative and a whiner and was out of the running.

The other candidate became a "yes" man. "He became a politician, changing his platform every ten minutes. But voters remember that. They begin to wonder what you really *do* stand for." Soon he was out too, and Berry was the new president.

Sylvia Porter told how one woman made herself stand

out in a field of competitors. Porter was introduced to Carole Sinclair, a woman who was being considered for the publisher position of *Sylvia Porter's Personal Finance Magazine*. After the first meeting, Sinclair sent Porter a letter filled with additional money-making ideas, including potential magazine articles and book ideas. Says Porter, "I look for someone with my desire and eagerness for new ventures." Sinclair got the job.

If you've decided you want to look outside your company, you'll need to find a headhunter for top-level jobs. Do not contact one blindly. Some recruiters, in an effort to ingratiate themselves with companies that could mean a lot of business for them, would turn you in. They'll call your company, tell them it's "common knowledge" you're looking around, and offer to find your replacement for them.

Contact people who have just moved to jobs at your level in your industry. Ask them which firms handled the placement and if they would recommend you to the firm.

An executive recruiter specializing in only top-level positions told me that almost all the women candidates they hear of are recommended by women. This implies we don't come as easily to men's minds as their male colleagues do when it comes to top management positions. To compensate, women who are asked for potential candidates should make sure they come up with some female names, or qualified women may not even be considered.

What are some hidden prejudices about women candidates? "Men are more suspicious of a woman's motives than a man's," the headhunter said. "They look for a hidden agenda with women and expect them to be super-ambitious. They think this means that women aren't loyal to a company and will leave for a small gain, while they don't think a man will. They also don't believe that a 45-

to-50-year-old woman just wants to move up. They sus-
pect some problem—probably, although they've never
said it to me, menopause."

How do clients look at job hopping? "They're fright-
ened by people who've stayed in one or two jobs for a very
long time. But on the other end, someone who's moved
eight to ten times by the time he or she is fifty also raises
flags." Temper those rules of thumb for the norms of your
industry.

The most common fear about a woman candidate, how-
ever, is that the male boss will feel inhibited around her.
That he won't be able to be himself. "That's where
women with a healthy sense of humor score well. You
need the ability to make people feel at ease with you. No
man's going to hire someone who makes him feel ner-
vous."

The executive recruiter warns against a woman turning
down a job offer because of an attractive counteroffer
made by her current firm. "Some companies take a wom-
an's leaving more personally than a man's. I've seen coun-
teroffers made just so the company could fire the woman
once they'd picked out a good replacement."

Her biggest complaints about women candidates are
those who waste her time. Some get into an interview and
say, "I'm not looking for a job. I'm perfectly happy where
I am." Another irritant is a woman who gets to the end of
the process, is offered the job, and then backs out—she is
not likely to become a candidate with the recruiting firm
in the future.

In fact the recruiter's most frustrating experience was a
former teacher with three years of sales who backed
down from an offered sales management position because
she was afraid she wasn't qualified enough. "No guts,"
snarled the headhunter. How this fits with the perception

of women being more ambitious and more likely to job-hop than men remains to be seen.

How have women blown interviews? One woman did well on her first interview, then blew it over lunch by talking about her personal life.

Another woman was asked by a recruiter if she had children. The candidate said, "That's illegal for you to ask." The candidate was correct but stupid. At this level you'd better be prepared to deal with these questions or keep getting rejected. An answer such as, "I have two children and a great live-in nanny who keeps everything running smoothly" answers the important question: Are your children going to be a problem in your performing this demanding job? If you don't have a nanny, compose some answer that reassures the company about your time commitments.

Similarly she advises single women who are in a stable relationship to drop some mention of it in passing. "Married men tend to fantasize the playing around they would do if they were single and project it onto single men and women. They worry you'll be out all the time and too exhausted to do your job."

Trying to pretend you're infallible is a big turnoff in interviews. Says the headhunter, "You shouldn't be reluctant to admit a failure. Saying you blew it on something only makes your successes more credible. And don't be afraid to admit you were fired. Everyone's been fired. If you try to hide it, you lose their trust. And for nothing."

Truthfulness is also recommended in salary. "If you feel your current salary makes you underpaid, then say so. Say you won't move for less than a 30 percent to 50 percent increase. But don't lie." While I agree that you shouldn't lie about your salary, I've seen a fair amount of truth stretching on bonus payments.

"And don't *ever* lie about having a degree," the head-

hunter advises. "We check. It's very stupid because degrees don't matter at the high levels. Nobody cares." She found some people have lied about their degrees so long they've come to believe it. "Check your résumé. If it's on there and it's a lie, take it off."

A meek and mild appearance causes immediate rejection. One client, referring to a candidate, said, "They'd eat her alive. Run all over her."

In interviews, you will occasionally get someone who will start pushing hard to see how you react when angry and under pressure. The usual form is to start attacking your qualifications and temperament for the job. "I don't see anything here that suggests you could handle the job," was a tactic used by one potential employer.

One woman, pushed into a similarly hostile scene, batted her eyelashes and turned on feminine charm to defuse and deflect the attack. The man hated it and rejected her as a candidate. "Yet," says the headhunter, "another man would have thought that was a good way out."

Don't bother coming on to the headhunter as though you were going to be the best of friends. "I have all the friends I need," she says. "And I resent someone thinking me stupid enough to be fooled by false friendship."

Although it's been said before, don't discuss money or benefits in the first meeting. Even if they bring it up, it's better to focus on the job and how you do or don't fit into it. "Make them love you, then tell them the price," is the advice.

Further advice is not to quit if you're unhappy at work. "Employers want people who have a job. Quitting shows an inability to take the heat. Nobody wants a quitter."

A final bit of advice is to beware of psychological testing. This headhunter finds 10 percent of the companies currently use it to screen management candidates and the

numbers are increasing. She believes these tests are biased against women executives.

"A case I had recently that was typical involved a woman candidate who went through all the interviews and was the clear choice. The company used an industrial psychologist consultant to test new hires over a certain level, so the candidate was sent to be tested. The company and this candidate had already agreed upon money, benefits, everything. Her references were great and her track record was a proved success.

"The tests showed her to be disruptive and overly aggressive, and to have poor people skills. The tester didn't worry at all about how she could have had poor people skills and yet been so successful and been so highly recommended. He went with his tests and reality be damned. The company backed out and hired a poor second choice. They didn't want to 'risk' it.

"I think we should ask," the headhunter concluded, "how many successful women presidents have industrial psychologists tested to determine what is 'normal' for this group and what isn't? And if that number is none or next to none, on what basis do they decide whether or not a woman will make a successful president?"

17

TIPS ON STARTING
YOUR OWN COMPANY

Whether it's because they always wanted to be their own boss, or because they don't think they'll get a fair shake in the corporate world, more and more women are starting their own companies.

Syndicated columnist Sylvia Porter says, "It's important to work for yourself, because then the failures and the successes are all yours."

"You can never be fired," says Lillian Katz, president and founder of Lillian Vernon. "That gives you the freedom to experiment. Learn what you love and what you do best. Then enter a field and structure the company based upon that. One thing you'll notice about entrepreneurs is they're maximizing their own fun. Of course, what's fun to one person can look like brutal work to another."

"How do you want to be?" asks Kay Koplovitz, president of USA Network. "You can choose. You don't even have to be the bad guy if you don't want to. And you set the corporate style, attitude, culture."

Chances for success are considerably better if you've worked for companies in the field of your prospective business. If you can work for an industry giant, you will have a real advantage in knowing their vulnerabilities. But you can kill your chances for success if you start out thinking too big. Enormous amounts of money are wasted on start-ups by former big business practitioners who don't zero-base-budget every expenditure.

"Be fully informed about the field you're entering," advises Ernesta Procope, president and founder of E. G. Bowman. "Get whatever degrees will help. I think it's absolutely necessary in today's competitive environment."

Probably the most important decision is what market niche you will occupy. You want an area with proved demand that will not be big enough to make the big boys salivate. They can outspend you and outlast you and you will not win.

Take the computer industry. IBM was incredibly slow in getting into personal computers. The original marketers had more time to establish themselves than they could have anticipated in their wildest dreams. Yet, of all the small computer companies that were there first, only Apple is given much of a chance of staying alive. And some analysts are betting against even them.

Meanwhile, with next to no fanfare, hundreds of computer peripherals companies have started and are flourishing. Most are in low-volume, fast-turnaround areas that a large powerful company with huge overhead and lead times must ignore.

Imogene Forte, president and founder of Incentive

Publications, says: "We studied what the big companies in our field were doing, so that we wouldn't do the same. When it's a big company versus a small company, your only edge is a quick turnaround."

"Start small," says Ernesta Procope. "The smaller you start, the less equity you have to give up for the financing. Frequently you can start part of what you want to end up with and grow it into the whole."

This is especially recommended for people walking around with start-up ideas they can't get funded. This is epidemic in the magazine publishing field. Yes, some people do get $8 million to start their own magazines. Some people have daddies on the boards of venture funds. Better to start your dream in a scaled-down version than to wait for megabucks to fall from the skies.

Ask everyone for advice. A neighbor is a comptroller? Ask for advice on how to set up your financial systems. Another neighbor is a salesperson? Ask for ideas on getting in to see difficult customers. You'll get some rejections, but most people love to give advice. It makes them feel important. Just remember, you don't have to take the advice.

Use suppliers for funding. Many suppliers will agree to delayed payments for a start-up project. A printer with downtime can be asked for sixty- or ninety-day terms. Suppliers of raw materials can be hit up for sixty-day terms. These people don't get equity, so use their money first!

Use your advantages over a big company. Jump on new trends quickly, while being ready to get out fast when the fad dies. Provide customized services.

Big business wants people who fit conveniently into slots. That means they pass up very smart, ambitious people with nontraditional backgrounds. These people can be a gold mine for you. Lillian Katz hires art majors as

catalog coordinators. "They have the eye for what's appealing. And they're motivated to succeed in a field where they won't starve. I've found artists I made into merchandise managers. A big corporation would never give them that chance."

Katz also finds personnel gold mines in teachers looking to get out. Big business offers them low-level entry positions. Katz hired one teacher as assistant to the president. This person started handling labor relations, then became director of one of her buildings, then moved to vice president of operations. "Teachers," says Katz, "have learned people management."

Try to give yourself a 25 percent cost overrun cushion. You will run into a lot of surprises, most of which are bad. If what you're selling is in no way a necessity item, expect recessions to cut sales by 30 to 50 percent. If your revenues are not yet up to plan, find a way to lower your costs. You have to be ruthless in protecting your cushion from seeping away, or when you really need it, you'll find yourself out of business.

Imogene Forte says, "You must do *whatever* it takes to make the company go. Starting this company was a full-time job in addition to holding regular jobs that paid the bills. We took no salaries; we reinvested everything. It was brutal." She succeeded because she absolutely refused to fail.

In that spirit, a magazine entrepreneur found a trick to raise expansion capital that you might be able to adapt to your circumstances. He had a small magazine, barely breaking even. His fixed costs were covered, and a larger circulation could put him in the black. He wanted to do a direct mail promotion to new subscribers, but it would cost him hundreds of thousands of dollars. He explained to his bank that the revenues from the subscriptions should

pay back the money within three months, but the bank said no.

After thinking about it, he went back to the bank and told them the company that printed his magazine was demanding a letter guaranteeing the print bill. He had always paid the print bill on time and the bank saw his current revenue stream was adequate to cover it in the future, so they gave him the letter. He immediately took the cash he'd planned to use for the print bill and spent it on direct mail. The printer didn't cut him off, because he gave them the bank's guarantee.

By the time the bank discovered what he'd done, the cash from the subscriptions was pouring in, just as he'd forecast, and he paid the back print bills. With the extra subscribers, he was able to raise his advertising prices. The magazine went from break-even to profitable. Sometimes entrepreneurs have to take risks like that.

Lest you delude yourself that having your own company is all glamour, here's an incident that happened to me as I was just starting to roll with *Sportswoman* magazine.

There were some mailers I needed to get out immediately if not sooner, so I'd been up the whole night completing them. Watching the sun rise, I decided to take them to the post office before going home to try to sleep. I dragged five dirty, heavy mail bags to the counter. I saw I was early; it would open in five minutes.

I was almost asleep on my feet when I heard someone else shuffle into line behind me. I glanced casually at the man and then turned back toward the counter. Slowly my brain processed what I'd seen. He looked terrible. He had beard stubble and red, half-closed eyes. His hands were clutching several envelopes with attached cards for registering.

A light started to go on in my head. I turned back and looked at him. Then I started to smile.

"Don't tell me," I said. "You're just starting your own business?"

He was taken aback. "How did you know?" Then he must have noticed how bad *I* looked.

"You too?" he asked.

We both started laughing.

INDEX